T0041719

Harry Potter™

FILM VAULT

VOLUME 9

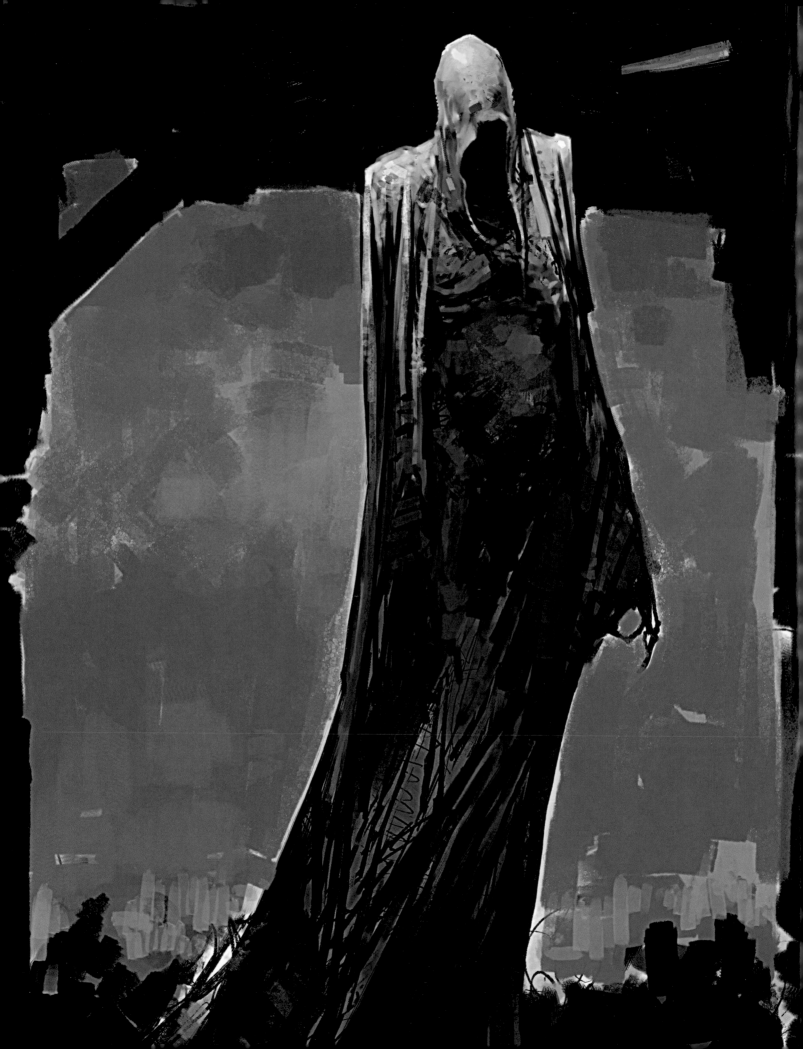

FILM VAULT

VOLUME 9

Goblins, House-Elves, and Dark Creatures

By Jody Revenson

WIZARDING WORLD

INSIGHT EDITIONS

San Rafael · Los Angeles · London

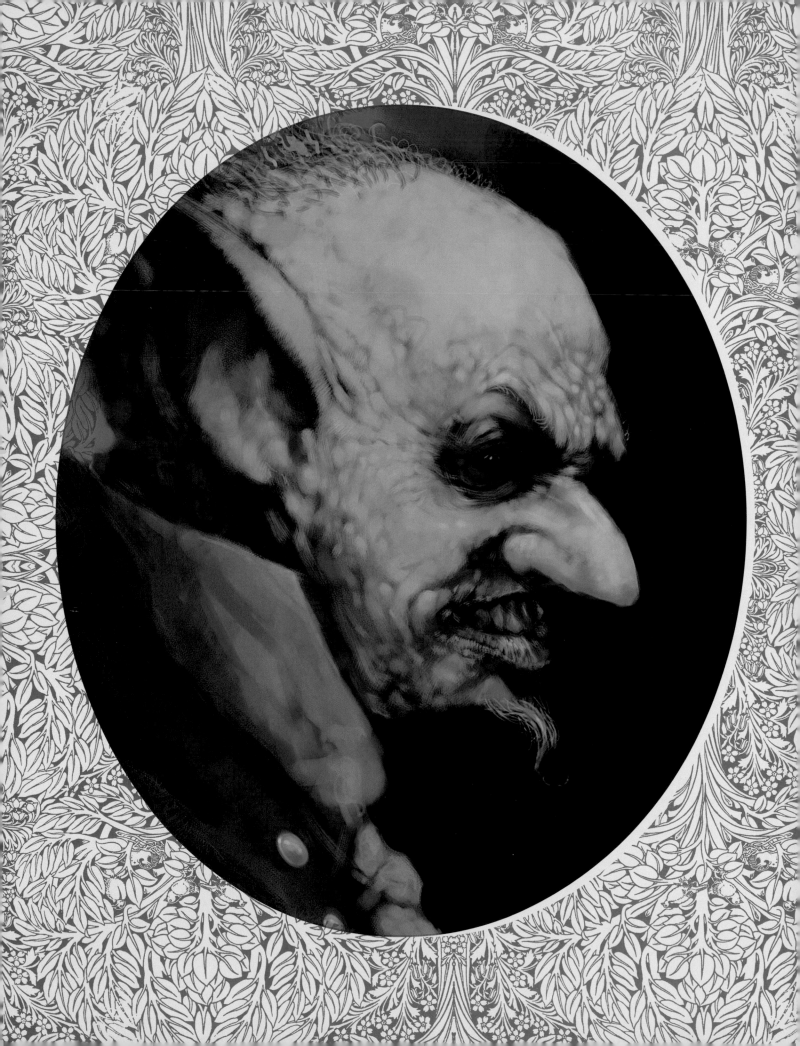

INTRODUCTION

Wen Harry Potter learns he's a wizard and that he might ultimately defeat the Dark Lord, Voldemort, he meets witches and wizards who will help him and witches and wizards who try to stop him. Harry also meets magical creatures that work with him or against him in his efforts to stop Voldemort from gaining ultimate power over the wizarding community.

"There are creatures in the Harry Potter films you've never seen before," says producer David Heyman. "And these creatures are obstacles that Harry needs to overcome to prove himself." The Basilisk that Harry (Daniel Radcliffe) fights in *Harry Potter and the Chamber of Secrets* is a creature of lore, not seen for one thousand years, so Harry must fight both the legend and the beast. In *Harry Potter and the Half-Blood Prince*, Harry encounters Inferi: corpses resurrected by Voldemort that guard one of his Horcruxes, which contains a piece of his splintered soul. The Inferi are both threatening and sympathetic, for they did not choose to become Dark creatures.

Voldemort and his followers place other Dark creatures in his path, such as the Basilisk, a forty-foot-long snake, that can kill any living creature with just a look into its eyes, and the black-shrouded Dementors with their soul-sucking Dementor's "kiss." Harry learns how to defeat them all.

Not all creatures that are scary are Dark, some are just big and stupid. In *Harry Potter and the Sorcerer's Stone*, Harry Potter, Hermione Granger, and Ron Weasley must overcome a mountain troll. But first they must overcome their fears. The troll's defeat gives them their first taste of victory. Other big creatures can be innocent and clumsy. In *Harry Potter and the Order of the Phoenix*, Harry, Hermione, and Ron meet the young giant Grawp, who is half-giant Hagrid's half-brother. "Harry and Ron think he's grubby and cumbersome," says Emma Watson (Hermione). "But Hermione thinks he's just a big kid with puppy dog eyes. To her, there's something so endearing about him." Grawp develops a sweet spot for her, too, and picks her up, but Hermione shows who's in control and gets him to gently put her down. "He may be made up of special effects," adds Watson, "but somehow he's so real."

Creatures Harry encounters during his years at Hogwarts sometimes become valuable allies, and years after their first encounter, they remember Harry's kindness and respect. These are kind and loyal creatures who fight by Harry's side, including the well-intentioned house-elf Dobby, who proves to be as fierce a warrior as any wizard. Dobby, who is first seen in *Chamber of Secrets*, is part of the working world, where house-elves serve one family for their entire lifetime (unless they receive a gift of clothing, which frees them from their servitude). Dobby works for the Malfoy family, and when he learns of plans to release the deadly Basilisk upon the non-pureblood students at Hogwarts, he strives to keep Harry safe, although his efforts generally backfire or result in mischief. Harry's sympathy for the house-elf and his strong moral compass direct him to set Dobby free, which makes Dobby even more loyal to Harry and his friends.

Harry meets Griphook the goblin, who works at Gringotts Wizarding Bank, in *Harry Potter and the Sorcerer's Stone* when the young wizard is still finding his place in a society that is brand new to him. Many years later, when Harry finds a way to stop Voldemort, he needs to employ Griphook's help. Although goblins historically do not get along with humans, the esteem Harry has always afforded him (and a deal to have the goblin-made Sword of Gryffindor returned to its makers) persuades Griphook to assist him.

"Scenes should be character defining," says Alfonso Cuarón, director of *Harry Potter and the Prisoner of Azkaban*, "even if those characters are creatures." Although made from special foam or special effects, the creatures encountered in the Harry Potter films have fully realized personalities, whether they are steadfast workers, mischief-makers, devoted friends, combatants, or just slow on the uptake.

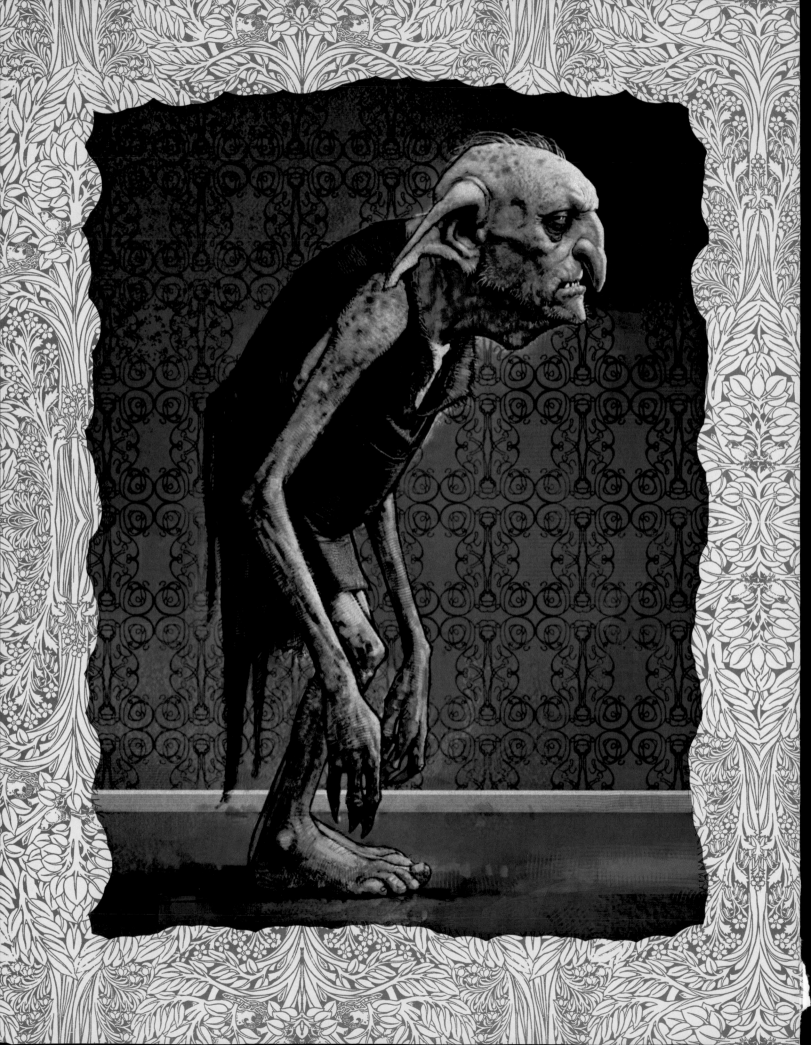

CHAPTER ONE

GOBLINS AND HOUSE-ELVES

In the wizarding world of the Harry Potter films, creatures of diverse types and species are employed for various occupations. House-elves serve wizarding families with unquestioning loyalty. For financial needs, goblins run the wizarding bank Gringotts, in Diagon Alley.

House-elf

A house-elf is bound to serve one wizarding family for his or her entire life. House-elves are dependable, loyal, and many are even fanatical in their service to their masters. When called upon, they can utilize incredibly powerful magic. House-elves can only be released from their servitude with the gift of an article of clothing from their master. While we meet only two house-elves in the Harry Potter films, the designers evoked very different personalities and looks in their realization of these creatures, and were given the rare opportunity to physically age these characters.

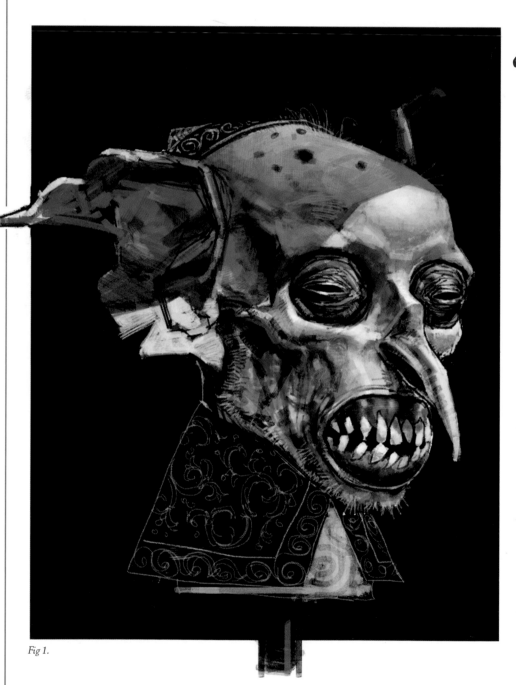

Fig 1.

" *Not to be rude or anything, but this isn't a great time for me to have a house-elf in my bedroom.*"
—HARRY POTTER
Harry Potter and the Chamber of Secrets film

Page 2. Concept art by Rob Bliss of a Dementor for *Harry Potter and the Prisoner of Azkaban*; Page 4. Concept art of a Gringotts goblin by Paul Catling for *Harry Potter and the Socerer's Stone*; Page 6. Kreacher, the irritable, irritating house-elf to the House of Black in artwork by Rob Bliss for *Harry Potter and the Order of the Phoenix*; Figs 1.—5. Harry Potter discovers the Black family's curious tradition of displaying the heads of their house-elves after their service ends when he visits number twelve, Grimmauld Place in *Harry Potter and the Order of the Phoenix*. Rob Bliss's concept artwork offers eerie and enthralling possibilities of noses, ears, teeth, and even skin textures.

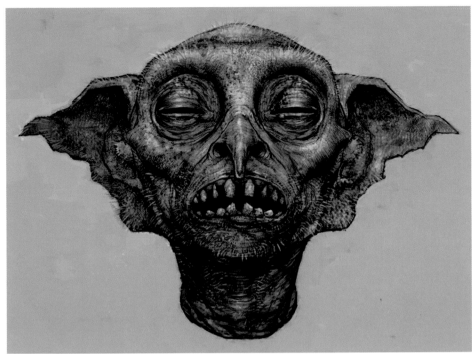

Fig 2.

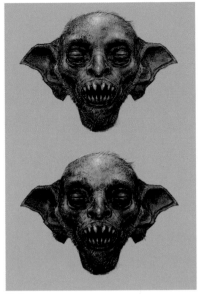

Fig 3.

"*Dobby is bound to serve one family forever. If they ever knew Dobby was here . . .*"

—DOBBY

Harry Potter and the Chamber of Secrets film

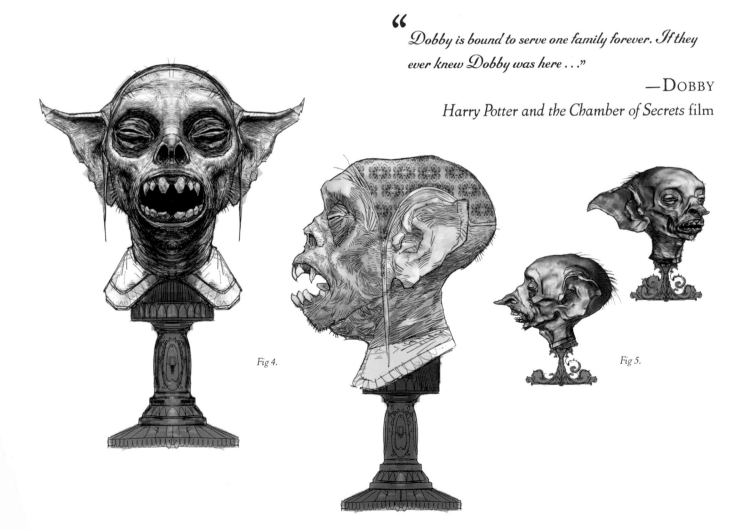

Fig 4.

Fig 5.

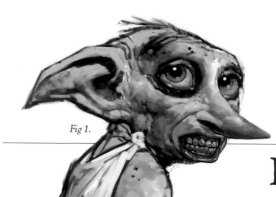

Fig 1.

DOBBY

Dobby, the house-elf who serves the Malfoy family, becomes a loyal friend to Harry in *Harry Potter and the Chamber of Secrets* when Harry finds a way to release Dobby from the Malfoy family's service. They are reunited in *Harry Potter and the Deathly Hallows – Part 1*, but sadly, Dobby is killed as he tries to rescue Harry and his friends.

A beloved and unique creature, Dobby, introduced in *Harry Potter and the Chamber of Secrets,* was the first fully computer-generated major character in the Harry Potter films. Dobby

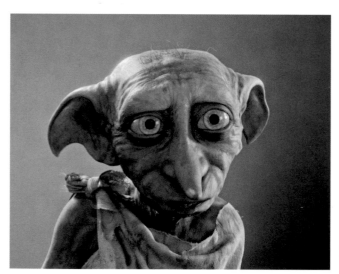

Fig 2.

went through many design iterations before the bat-eared, soulfully big-eyed, pointy-nosed house-elf emerged. The designers took into account Dobby's background as servant to the Malfoy family, and so he was given a pasty, sallow "prisoner-of-war" appearance, enhanced by grimy skin and little or no muscle tone. His hunched posture reflects his years of abuse at the hands of the Malfoys.

Once Dobby's look was established, the creature shop fashioned a full-size, fully articulated, fully painted silicone model that left no wrinkle unfolded. With a completely functioning armature inside, the model was posable for lighting reference and for actors to create eyelines on the set. The model was also

used in the film for a few over-the-shoulder shots. Dobby's movement for *Chamber of Secrets* was achieved via motion capture technology. Actor Toby Jones, who voiced the house-elf, enacted his scenes, which would then have his facial expressions and physicality imbued into the digital performance.

The digital realism that comes from cyberscanning a model so meticulously crafted can be measured by the emotional impact of the CGI character. For Dobby's final appearance, in *Harry Potter and the Deathly Hallows – Part 1*, the house-elf was given a softer, more humanized look, which the filmmakers felt would give him an even greater sympathetic resonance. His neck and face were smoothed out, his arms were shortened, and his eyes were made less bulbous. As Dobby passed away in Harry's arms, the visual effects designers had his eyes appear watery, and slowly desaturated the texture of his skin to make it successively paler. Dobby's death at Shell Cottage involved not only the CGI version of the character but also the life-size model and even body doubles that were composited into the live action.

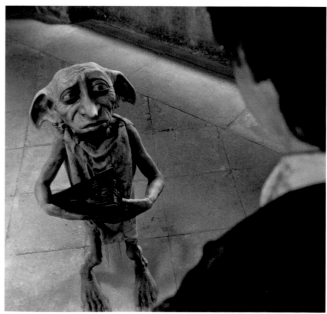

Fig 3.

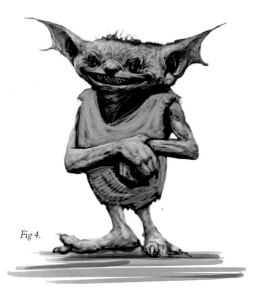

Fig 4.

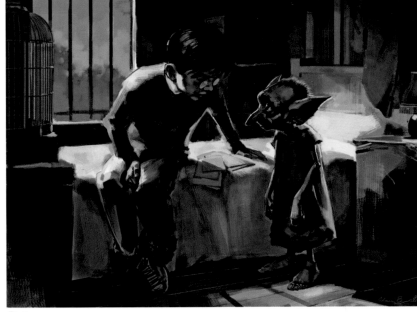

Fig 5.

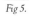

> *Dobby never meant to kill anyone!*
> *Dobby only meant to maim . . . or seriously injure.*"
>
> —DOBBY
>
> *Harry Potter and the Deathly Hallows — Part 1* film

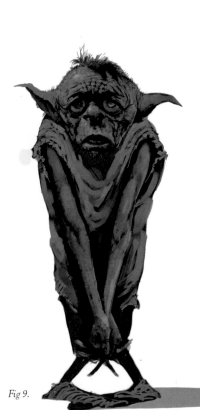

Fig 6.

Fig 1. Dobby the house-elf by Rob Bliss for *Harry Potter and the Chamber of Secrets*; Figs 2. & 3. Dobby comes to the Dursleys' house to persuade Harry not to return to Hogwarts in scenes from *Chamber of Secrets*; Figs 4., 6.—9. Visual development studies for Dobby by various artists; Fig 5. Harry lets Dobby know that nothing will stop him from going back to Hogwarts in artwork by Adam Brockbank.

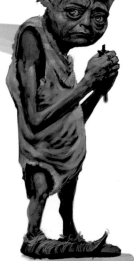

Fig 7.

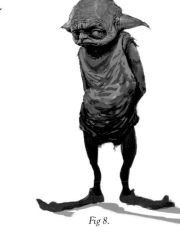

Fig 8.

Fig 9.

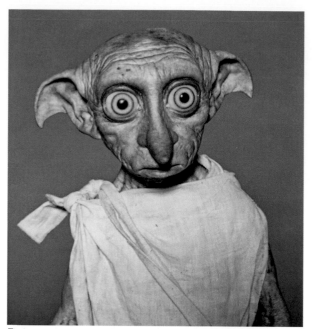

Fig 1.

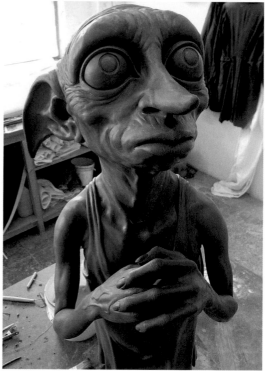

Fig 2.

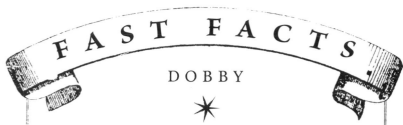

DOBBY

✴

I. FIRST FILM APPEARANCE:
Harry Potter and the Chamber of Secrets

II. ADDITIONAL FILM APPEARANCE:
Harry Potter and the Deathly Hallows – Part 1

III. LOCATIONS: Number four, Privet Drive; Hogwarts;
number twelve, Grimmauld Place; Malfoy Manor; Shell Cottage

IV. TECH TALK: The animators always had
Dobby's smile turn up on the left side whether or
not he is facing in that direction on-screen.

V. DESCRIPTION FROM *HARRY POTTER AND THE
CHAMBER OF SECRETS* BOOK, CHAPTER TWO:
*"The little creature on the bed had large, bat-like ears and
bulging green eyes the size of tennis balls."*

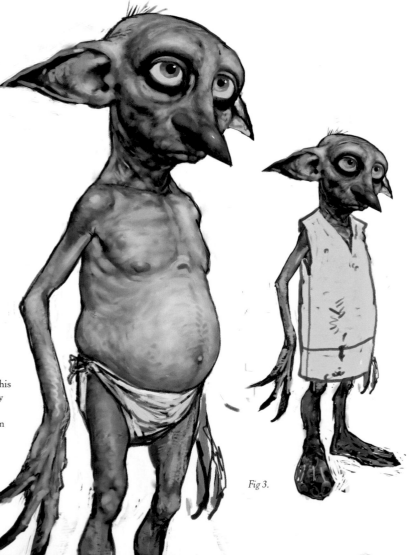

Figs 1. & 2. Maquettes of Dobby at different stages of creation for
Harry Potter and the Chamber of Secrets; Fig 3. Studies of Dobby and his
wrapped-towel attire by Rob Bliss; Fig 4. Early concept art of Dobby
covered in tea towels by an unknown artist; Fig 5. Head studies of
Dobby by Rob Bliss; Fig 6. Dobby's gravestone by Hattie Storey from
Harry Potter and the Deathly Hallows – Parts 1 and 2; Fig 7. Early
concept art of a long-nosed Dobby by an unknown artist.

Fig 3.

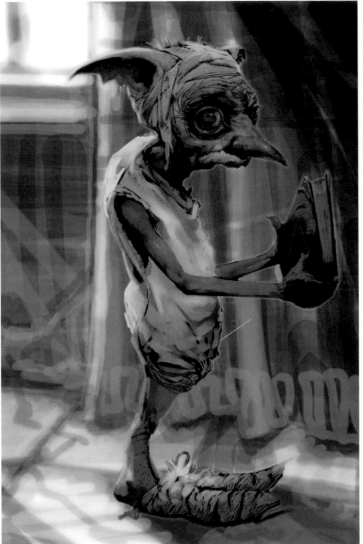

Fig 4.

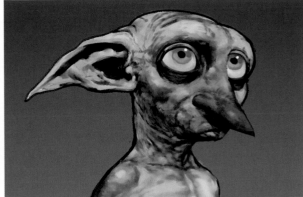

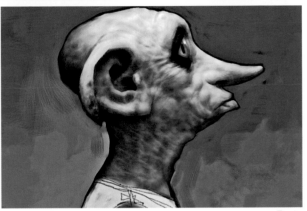

Fig 5.

" *Master has presented Dobby with clothes!*
Dobby is free!"

—DOBBY

Harry Potter and the Chamber of Secrets film

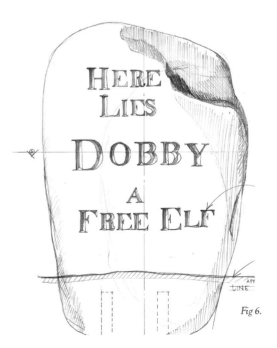

HERE
LIES

DOBBY

A
FREE ELF

Fig 6.

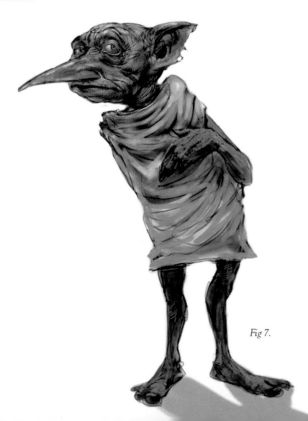

Fig 7.

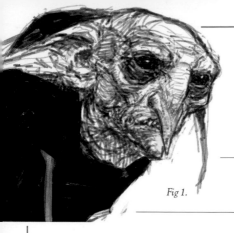

Fig 1.

KREACHER

When Harry Potter is taken to number twelve, Grimmauld Place in *Harry Potter and the Order of the Phoenix*, he meets Kreacher, the house-elf who serves the Black family. Devoted to his pure-blood wizard masters, Kreacher despises their Dumbledore-loyal son, Sirius, and the members of the Order who meet at Grimmauld Place. In *Harry Potter and the Deathly Hallows – Part 1*, Kreacher assists Harry in finding the real Horcrux locket.

Kreacher could be considered the exact opposite of Dobby, even if they are from the same species. The designers enjoyed creating Kreacher's aged, collapsing skin, and long, dragging ears (complete with ear hair). Kreacher was given a hunched back, a dewlap, rheumy eyes, and a crooked, stooped stance that exudes distaste and intolerance. Whereas Dobby bubbled with exuberant movement, Kreacher was slow and plodding, almost immobile. Kreacher was voiced by Timothy Bateson for *Order of the Phoenix*, and then Simon McBurney for *Deathly Hallows – Part 1*. For his final appearance, Kreacher also "had a little work done." His nose was shortened, his skin was smoothed out, and his ears (and ear hair) were trimmed.

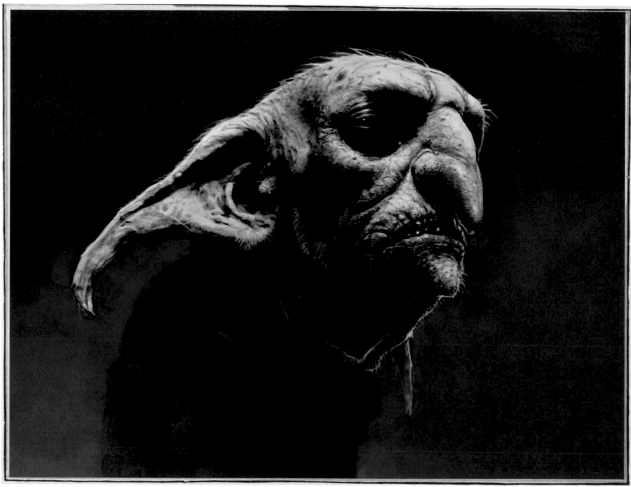

Fig 2.

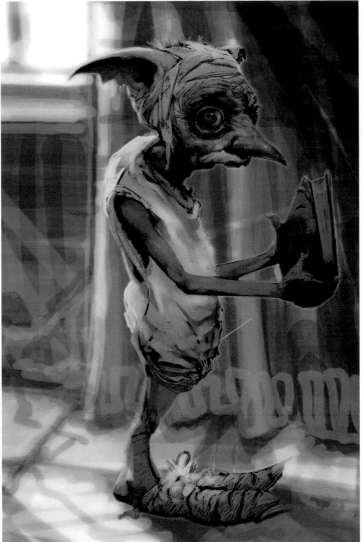

Fig 4.

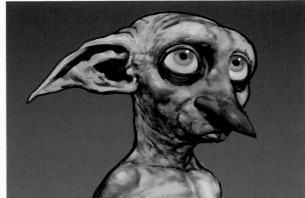

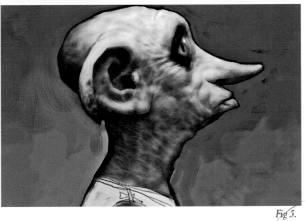

Fig 5.

" *Master has presented Dobby with clothes!*
*Dobby is free!***"**

—DOBBY

Harry Potter and the Chamber of Secrets film

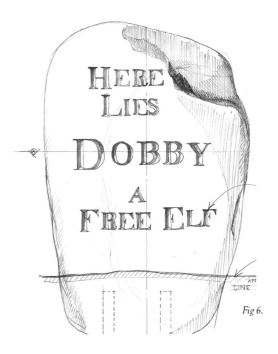

HERE
LIES

DOBBY

A
FREE ELF

Fig 6.

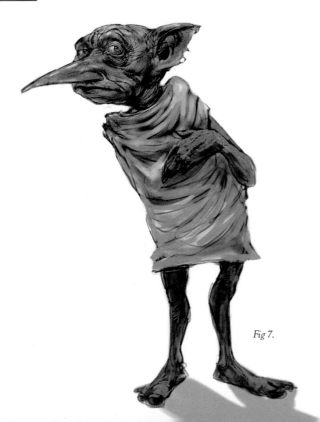

Fig 7.

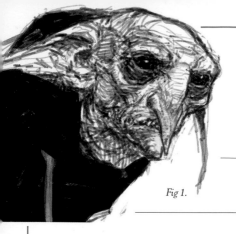
Fig 1.

KREACHER

When Harry Potter is taken to number twelve, Grimmauld Place in *Harry Potter and the Order of the Phoenix*, he meets Kreacher, the house-elf who serves the Black family. Devoted to his pure-blood wizard masters, Kreacher despises their Dumbledore-loyal son, Sirius, and the members of the Order who meet at Grimmauld Place. In *Harry Potter and the Deathly Hallows – Part 1*, Kreacher assists Harry in finding the real Horcrux locket.

Kreacher could be considered the exact opposite of Dobby, even if they are from the same species. The designers enjoyed creating Kreacher's aged, collapsing skin, and long, dragging ears (complete with ear hair). Kreacher was given a hunched back, a dewlap, rheumy eyes, and a crooked, stooped stance that exudes distaste and intolerance. Whereas Dobby bubbled with exuberant movement, Kreacher was slow and plodding, almost immobile. Kreacher was voiced by Timothy Bateson for *Order of the Phoenix*, and then Simon McBurney for *Deathly Hallows – Part 1*. For his final appearance, Kreacher also "had a little work done." His nose was shortened, his skin was smoothed out, and his ears (and ear hair) were trimmed.

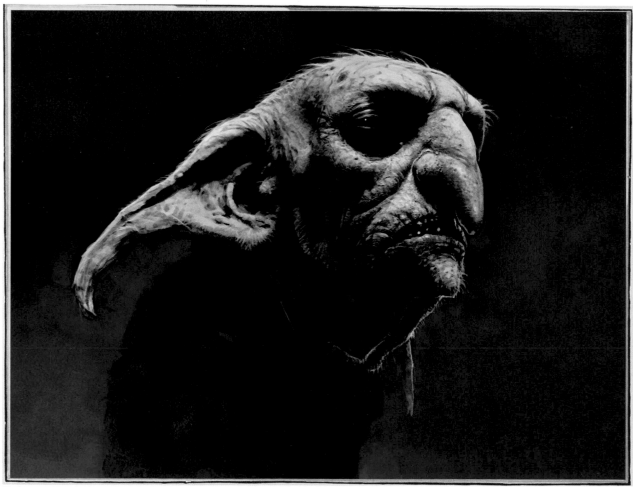
Fig 2.

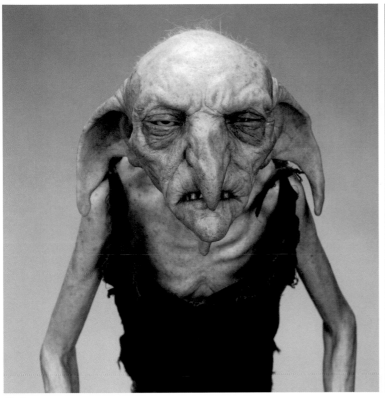

Fig 3.

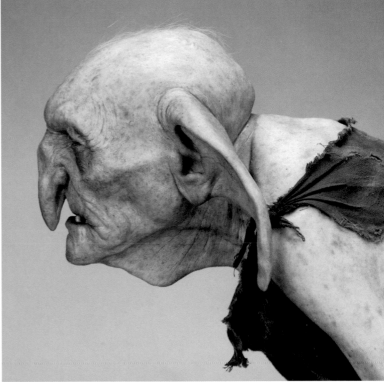

Fig 4.

> " *Nasty brat standing there as bold as brass. Harry Potter, the boy who stopped the Dark Lord. Friend of Mudbloods and blood-traitors alike. If my poor mistress only knew . . .*"

—KREACHER

Harry Potter and the Order of the Phoenix film

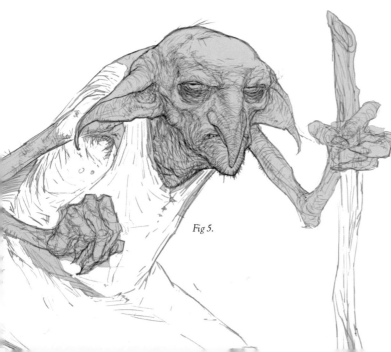

Fig 5.

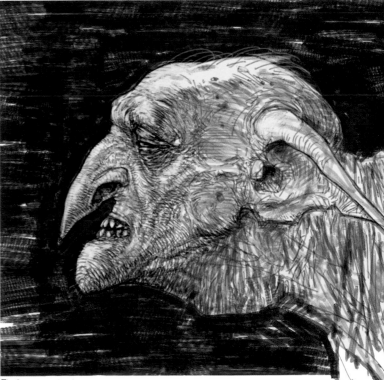

Fig 6.

Fig 1. Kreacher by Rob Bliss for *Harry Potter and the Order of the Phoenix*;
Fig 2. A color study of Kreacher by Rob Bliss; Figs 3. & 4. Maquette of Kreacher;
Figs 5. & 6. Kreacher sketches by Rob Bliss for *Order of the Phoenix*.

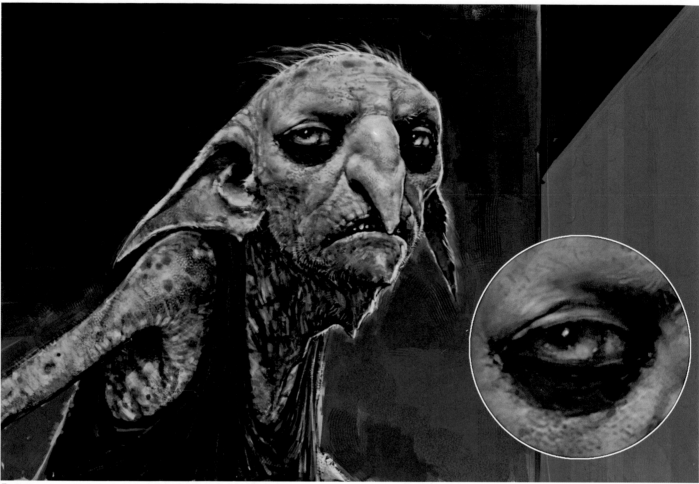

Fig 1.

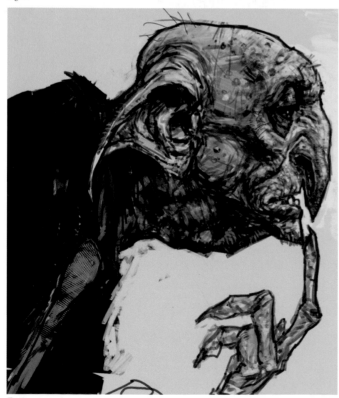

Fig 2.

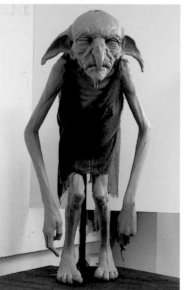

Fig 3.

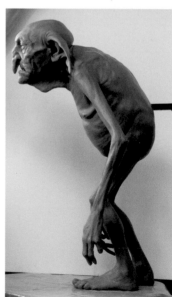

Fig 4.

Fig 1. Color study of Kreacher with a close-up of his eye by Rob Bliss for *Harry Potter and the Order of the Phoenix*; Fig 2. A contemplative Kreacher by Rob Bliss; Figs 3. & 4. Maquette of Kreacher; Fig 5. Ear studies by Rob Bliss; Fig 6. Kreacher insults Harry (Daniel Radcliffe) in the Black family Tapestry Room in a scene from *Order of the Phoenix*; Fig 7. A shorter-nosed Kreacher by Rob Bliss.

" *Kreacher lives to serve the*
Noble House of Black."

—KREACHER

Harry Potter and the Order of the Phoenix film

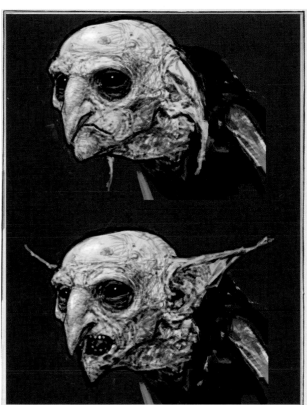

Fig 5.

KREACHER
✦

I. FIRST FILM APPEARANCE:
Harry Potter and the Order of the Phoenix

II. ADDITIONAL FILM APPEARANCE:
Harry Potter and the Deathly Hallows – Part 1

III. LOCATION: Number twelve, Grimmauld Place

IV. DESIGN NOTE: The designers wanted Kreacher
to be "revolting and ghastly in every way."

V. DESCRIPTION FROM *HARRY POTTER AND THE
ORDER OF THE PHOENIX* BOOK, CHAPTER SIX:
"*Its skin seemed to be several times too big for it and though it was
bald like all house-elves, there was a quantity of white hair growing
out of its large, bat-like ears. Its eyes were a bloodshot and watery
gray, and its fleshy nose was large and rather snoutlike.*"

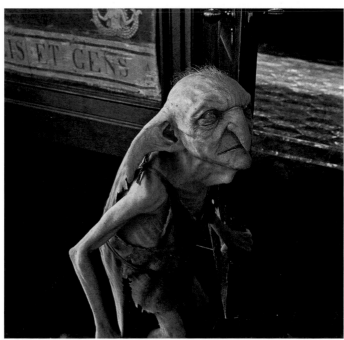

Fig 6.

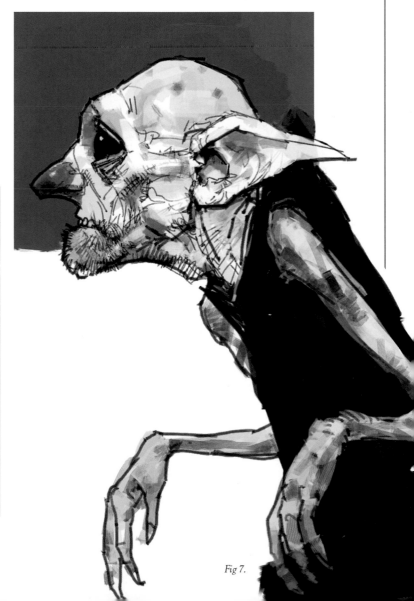

Fig 7.

Goblin

Goblins in the Harry Potter films act as bank officials and tellers at Gringotts Wizarding Bank in Diagon Alley. In the films, these creatures were given long fingers, long ears, and long noses as defining characteristics. Hagrid and Harry are taken by the goblin Griphook to withdraw money from the Potter family vault in *Harry Potter and the Sorcerer's Stone*. Harry, Griphook, Hermione Granger, and Ron Weasley (Rupert Grint), deceive the Gringotts goblins in *Harry Potter and the Deathly Hallows – Part 2* to break into the Lestranges' vault.

The creature designers for the Harry Potter films realized early on that the goblins' most important feature was their character, and so they created interesting character types that they then "goblinized." Each goblin was individually designed, with their personalities perceptible in their distinctive ears, chins, and noses.

In the ten years between the goblins' first appearance in *Harry Potter and the Sorcerer's Stone* and their final appearance in *Harry Potter and the Deathly Hallows – Part 2*, the technology involved in producing the prosthetic pieces that created the goblins' look greatly advanced. While the goblin heads for both films were cast in silicone, modern silicone now moves and feels like flesh. In *Deathly Hallows – Part 2*, more than sixty goblins were needed to inhabit the bank for the film, and so the creature shop put together an assembly line of makeup artists to paint goblin faces and hands, and insert hair and eyelashes one strand at a time. The goblin prosthetics could not be reused after they were removed at the end of the day's filming, and so multiples of every goblin head were created and duplicated for each day of the shooting schedule.

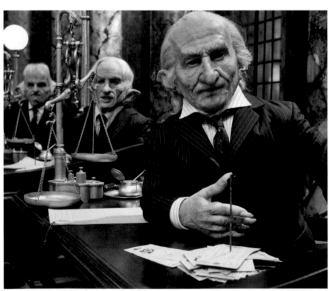

Fig 1.

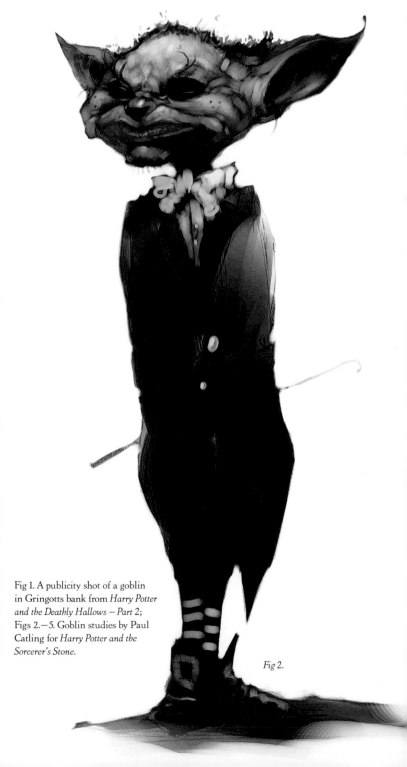

Fig 1. A publicity shot of a goblin in Gringotts bank from *Harry Potter and the Deathly Hallows – Part 2*; Figs 2.—5. Goblin studies by Paul Catling for *Harry Potter and the Sorcerer's Stone*.

Fig 2.

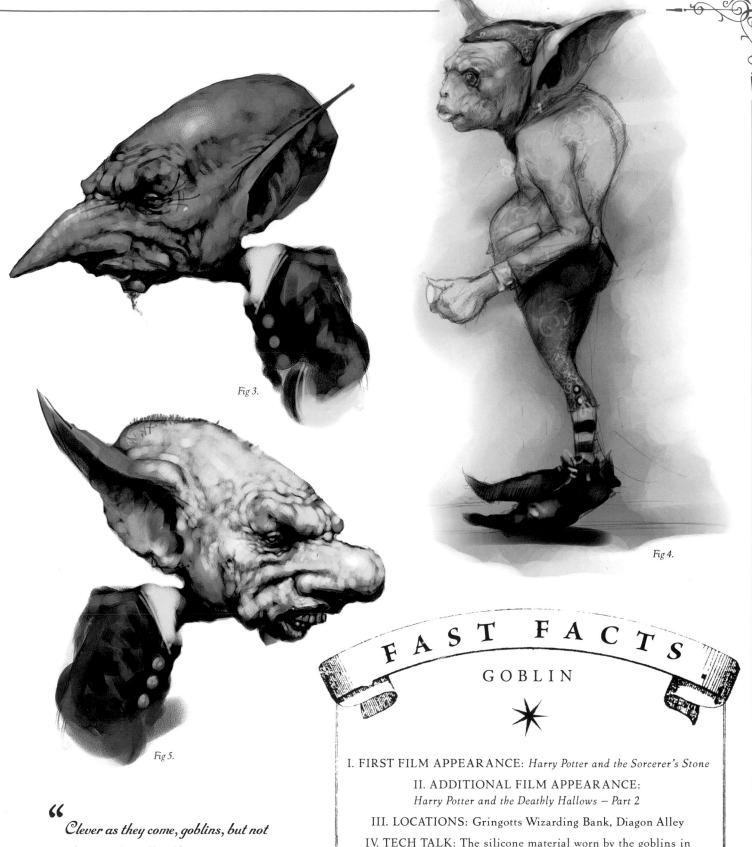

Fig 3.

Fig 4.

Fig 5.

"*Clever as they come, goblins, but not the most friendly of beasts.*"

—RUBEUS HAGRID
Harry Potter and the Sorcerer's Stone film

FAST FACTS

GOBLIN

✶

I. FIRST FILM APPEARANCE: *Harry Potter and the Sorcerer's Stone*

II. ADDITIONAL FILM APPEARANCE:
Harry Potter and the Deathly Hallows – Part 2

III. LOCATIONS: Gringotts Wizarding Bank, Diagon Alley

IV. TECH TALK: The silicone material worn by the goblins in
Deathly Hallows – Part 2 comes up to body temperature when applied.

V. DESCRIPTION FROM *HARRY POTTER AND THE
SORCERER'S STONE* BOOK, CHAPTER THREE:
"*The goblin was about a head shorter than Harry. He had a swarthy, clever
face, a pointed beard, and, Harry noticed, very long fingers and feet.*"

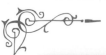

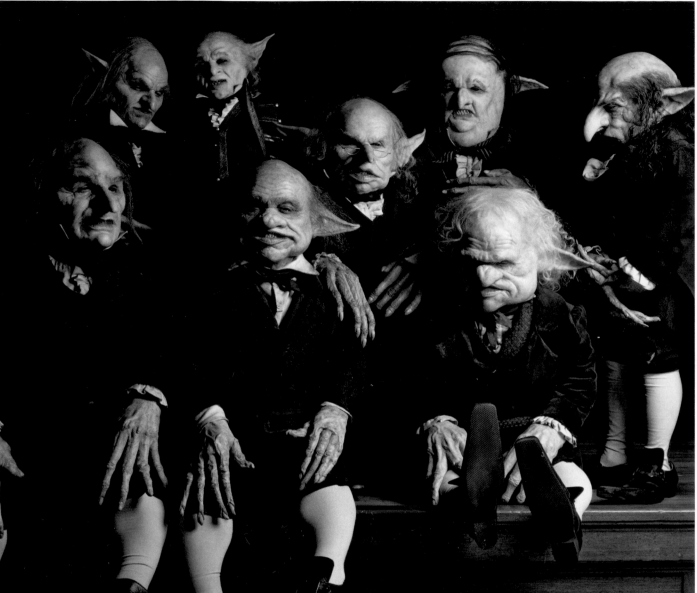

Fig 1.

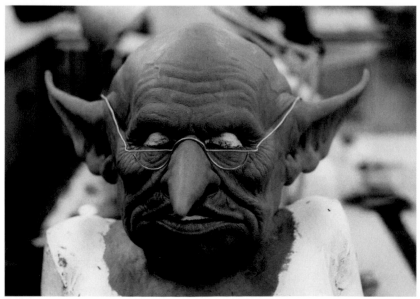

Fig 2.

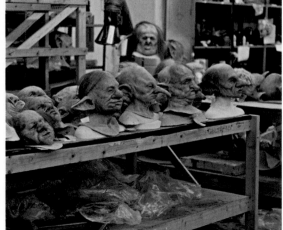

Fig 3.

GRIPHOOK

Griphook first meets Harry Potter in *Harry Potter and the Sorcerer's Stone* when the Gringotts worker guides him to the Potter family vault. They meet again in *Harry Potter and the Deathly Hallows – Parts 1 and 2*, when Griphook strikes a deal with Harry, who needs his help to break into the Lestranges' vault.

Fig 4.

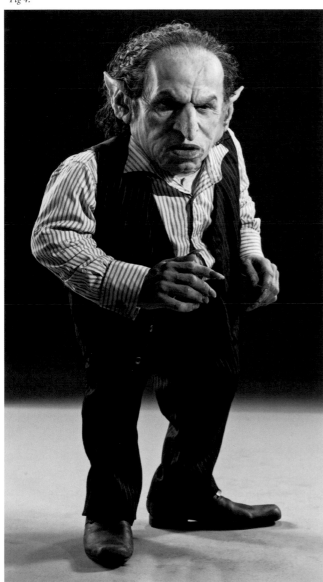

Griphook was played by veteran actor Warwick Davis, one of his many roles in the Harry Potter series. Transforming into Griphook for *Deathly Hallows – Parts 1 and 2* took four hours, which included wearing contact lenses and dentures with very sharp teeth that made it difficult to speak. It took another hour after shooting to remove the makeup. Davis also played the bank teller goblin who takes Harry Potter's vault key in *Harry Potter and the Sorcerer's Stone*, Hogwarts Professor Filius Flitwick, and the Hogwarts Choir Director in *Harry Potter and the Prisoner of Azkaban*. He also had a cameo in *Harry Potter and the Order of the Phoenix* as a goblin who lost Galleons trading on the potions market.

Fig 5.

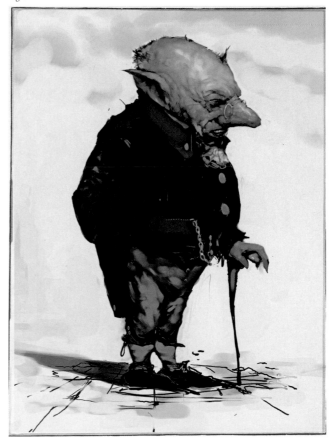

Fig 1. Gringotts goblins pose in a publicity shot for *Harry Potter and the Sorcerer's Stone*. Warwick Davis is at the center, playing a bank teller;
Fig 2. Prosthetic head piece model for the bank teller goblin.

Fig 3. The creature shop displays the goblin head prosthetics for *Sorcerer's Stone*;
Fig 4. Warwick Davis as Griphook in *Harry Potter and the Deathly Hallows – Part 2*;
Fig 5. Visual development artwork of Griphook by Paul Catling.

FAST FACTS

GRIPHOOK

✶

I. FIRST FILM APPEARANCE: *Harry Potter and the Sorcerer's Stone*

II. ADDITIONAL FILM APPEARANCE:
Harry Potter and the Deathly Hallows – Part 2

III. LOCATIONS: Gringotts Wizarding Bank, Shell Cottage

IV. TECH TALK: The part of Griphook in *Harry Potter and the Sorcerer's Stone* was physically played by Verne Troyer; Warwick Davis provided only the voice.

V. DESCRIPTION FROM *HARRY POTTER AND THE DEATHLY HALLOWS* BOOK, CHAPTER TWENTY-FOUR:
"Harry noted the goblin's sallow skin, his long thin fingers, his black eyes. . . . His domed head was much bigger than a human's."

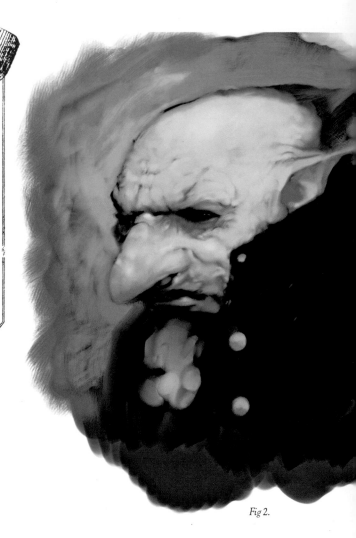

Fig 2.

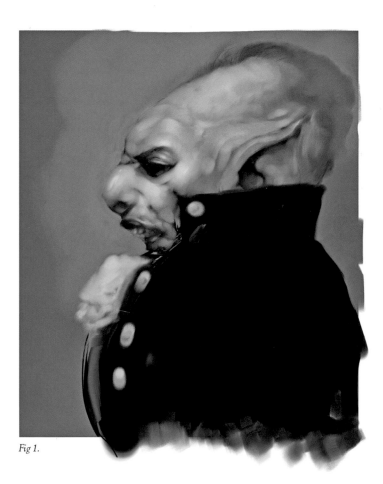

Fig 1.

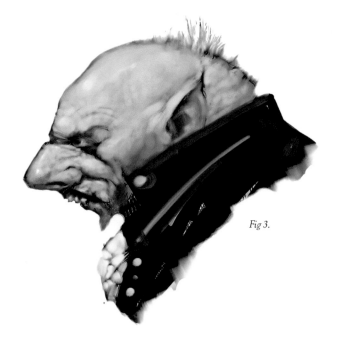

Fig 3.

Figs 1.–6. Paul Catling's portrayals of Griphook for *Harry Potter and the Sorcerer's Stone* are clothed in Dickensian-style suits, which was the costume department's idea for the wardrobe for the first film.

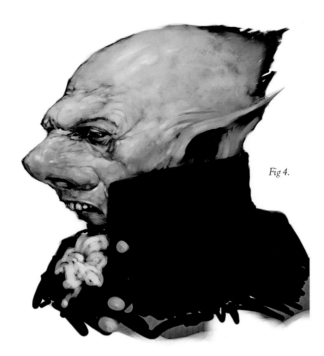

Fig 4.

> " *I said I'd get you in. I didn't say anything about getting you out.*"
>
> —GRIPHOOK
>
> *Harry Potter and the Deathly Hallows — Part 2* film

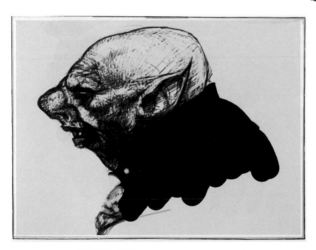

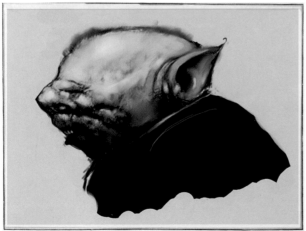

Fig 5.

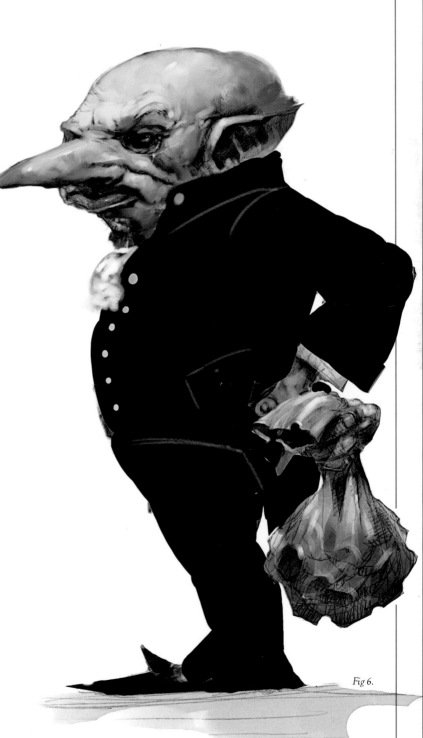

Fig 6.

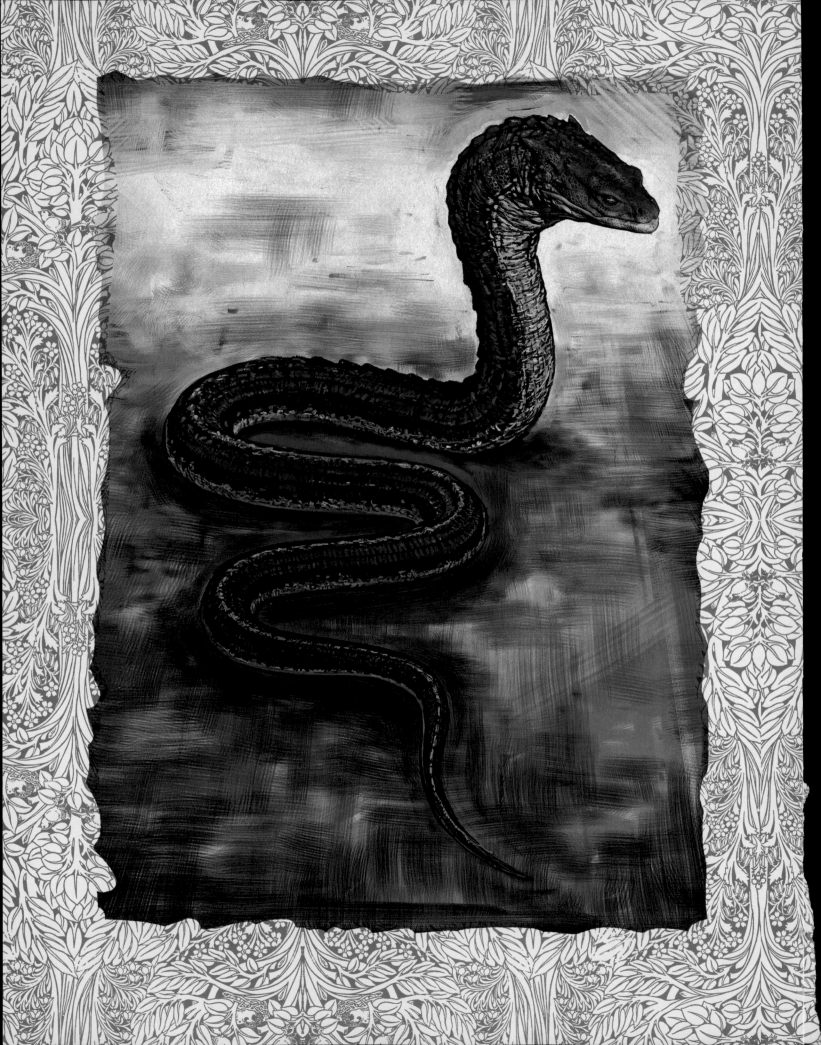

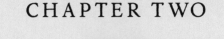

DARK CREATURES

The wizarding world depicted in the Harry Potter films includes creatures that would haunt the most horrible of nightmares, many of them engaged by Lord Voldemort in his pursuit of power. Twice, Voldemort opens the Chamber of Secrets to release the Basilisk, whose stare can turn its victims to stone. The Dark Lord also enlists the Dementors during his second rise to power and uses the Inferi as part of his arsenal to guard his Horcrux locket.

Basilisk

The titular location of *Harry Potter and the Chamber of Secrets* contains a thousand-year-old snake—the Basilisk—originally under the control of Salazar Slytherin. In the years since the Basilisk's containment, only one student has been able to command it: Tom Riddle. When the Basilisk is released once more during the events of *Harry Potter and the Chamber of Secrets*, it is up to Harry to slay the beast and save the school.

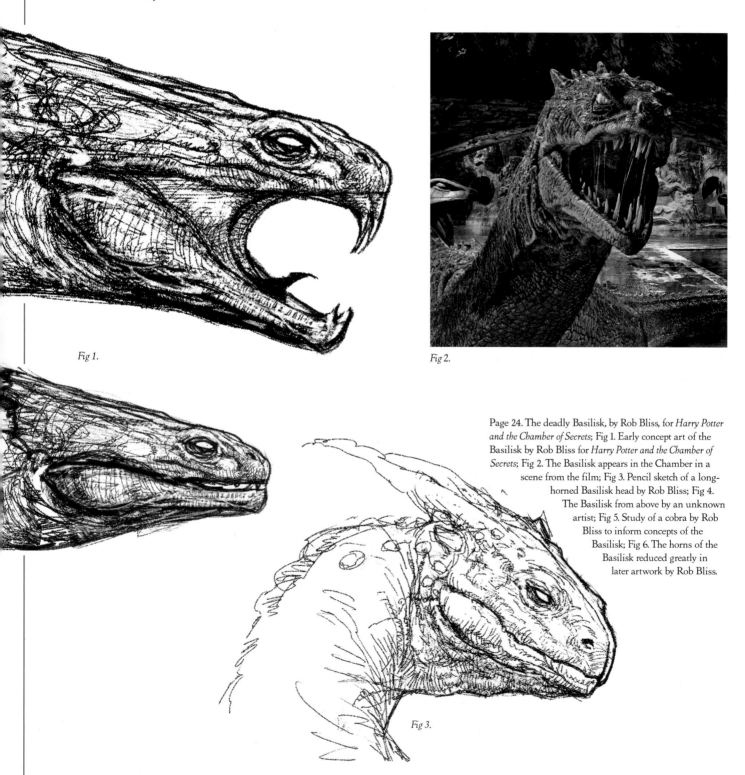

Fig 1.

Fig 2.

Page 24. The deadly Basilisk, by Rob Bliss, for *Harry Potter and the Chamber of Secrets*; Fig 1. Early concept art of the Basilisk by Rob Bliss for *Harry Potter and the Chamber of Secrets*; Fig 2. The Basilisk appears in the Chamber in a scene from the film; Fig 3. Pencil sketch of a long-horned Basilisk head by Rob Bliss; Fig 4. The Basilisk from above by an unknown artist; Fig 5. Study of a cobra by Rob Bliss to inform concepts of the Basilisk; Fig 6. The horns of the Basilisk reduced greatly in later artwork by Rob Bliss.

Fig 3.

The Basilisk that lives deep below Hogwarts in *Harry Potter and the Chamber of Secrets* has a dragon-shaped head that literally heightens its exaggerated reptilian body. Bony, thorny, and a little slimy, the Basilisk was fully intended to be brought to life inside a computer. Visual development research included observation of live creatures, including an eight-foot-long Burmese python named Doris. A model was produced to be cyberscanned, but as there was a need for a prop of the Basilisk's shed skin to lie in the Chamber, a full-scale model of the snake was made, and so the creature shop constructed the Basilisk's first forty feet of discarded snakeskin in urethane rubber.

The filmmakers decided that it would be better for Daniel Radcliffe (Harry Potter) to fight a full-size practical Basilisk mouth as he battles to save Ginny Weasley's life. The creature shop was happy to comply, but realized that they should sculpt more than just the teeth and the inside of the mouth; they should sculpt the entire head, which would lessen the amount of CG shots needed. The filmmakers agreed, and then asked if the sculpt could extend to the neck. Then, they asked if the jaw could be made to open and if the mouth could move up and down. And if the Basilisk's nose could move when it is stabbed. And if its eyes and eyelids could move even after it is blinded. And if its fangs could hinge backward, as any venomous snake's does, so that it could close its mouth. So, in addition to the full-size model of the shed snakeskin, another full-size practical Basilisk was constructed. This snake was even able to slither forward on a track laid on the floor to close in on Harry in the fight scene. The model used Aquatronics, employed to enhance the Basilisk's smooth glides and mouth movements; cable controls retracted its fangs.

Fig 4.

Fig 5.

Fig 6.

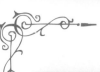

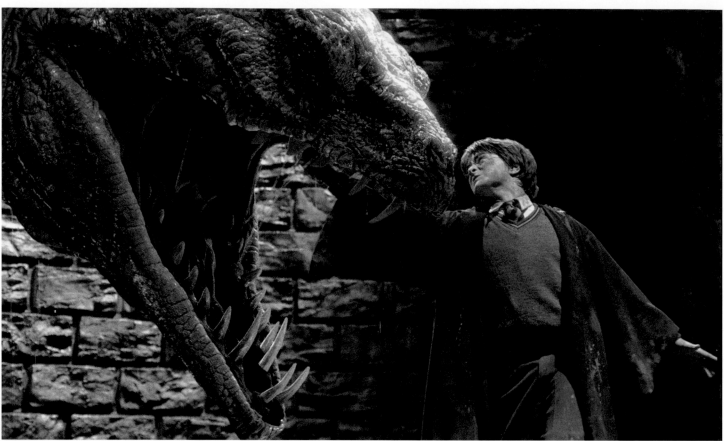

Fig 1.

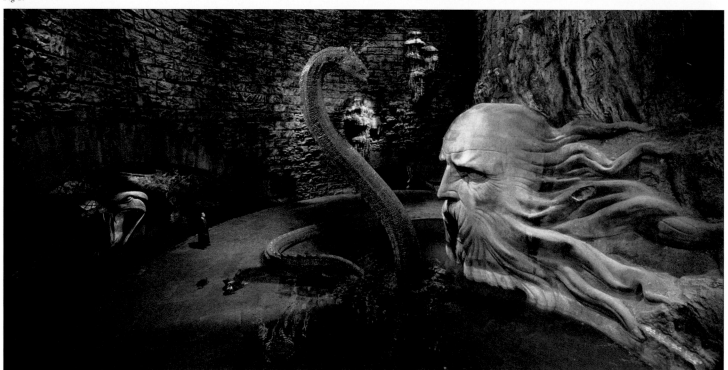

Fig 2.

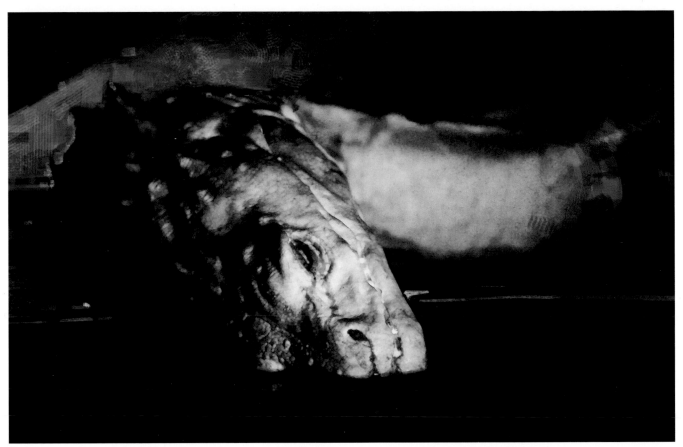

Fig 3.

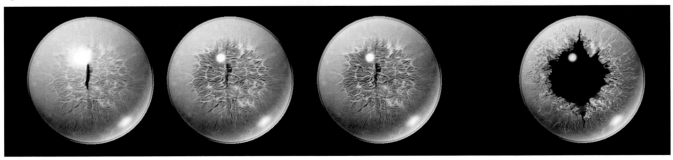

Fig 4.

Fig 5.

"Of the many fearsome beasts that roam our land, none is more deadly than the Basilisk. Capable of living for hundreds of years, instant death awaits any who meet this giant serpent's eye."

—HARRY POTTER, READING FROM
A TORN PAGE OF A LIBRARY BOOK
Harry Potter and the Chamber of Secrets film

Fig 1. Harry (Daniel Radcliffe) defeats the Basilisk in a scene from *Harry Potter and the Chamber of Secrets*; Fig 2. The death throes of the Basilisk; Fig 3. Development art of the Basilisk in death's repose by Rob Bliss; Fig 4. Studies of the Basilisk's eye by Rob Bliss; Fig 5. Early concept sketch by Rob Bliss.

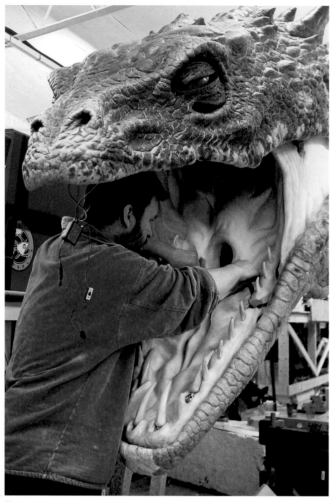

Fig 1.

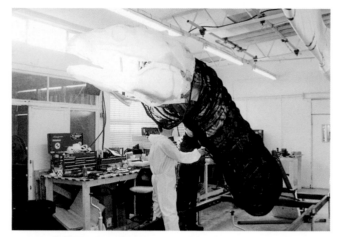

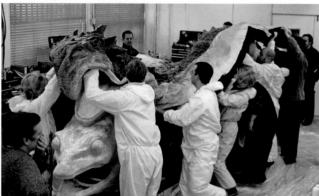

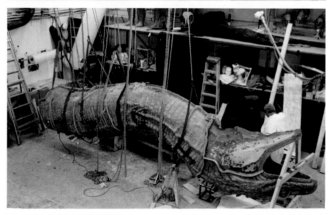

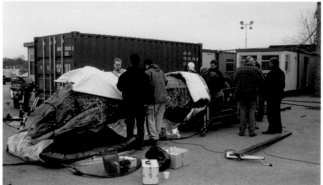

Figs 2.– 5.

In order to create the correct shape, the creature's foam latex exterior skin needed to be laid over a tubular or hexagonal structure with long sides made of aluminum to ensure that the design didn't become too heavy or unwieldy. This could only be accomplished by machine work that would be complicated and laborious. Or so they thought. In a casual remark, one of the creature shop crew suggested using ladders. Aluminum ladders were already strong and lightweight and were strengthened even more by modifications made to place them under the Basilisk skin. Parts of the Basilisk were recycled to build the Hungarian Horntail's body for *Harry Potter and the Goblet of Fire* when it is held in a cage. For *Harry Potter and the Deathly Hallows – Part 2*, the creature department built a new, fang-filled skeleton of the Basilisk.

Fig 6.

Figs 1.—5. Construction of the Basilisk in the creature shop included laying a forty-foot-long skin over a structure of aluminum ladders; Fig 6. Ron Weasley and Hermione Granger return to the Chamber of Secrets for a Basilisk's tooth in artwork by Adam Brockbank for *Harry Potter and the Deathly Hallows — Part 2*; Fig 7. The life-size Basilisk is sprayed down before a scene for *Harry Potter and the Chamber of Secrets.*

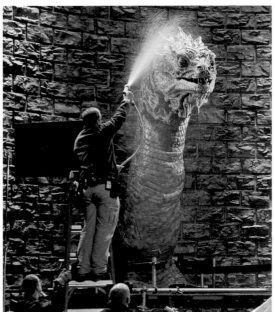

Fig 7.

FAST FACTS

BASILISK

✳

I. FILM APPEARANCE: *Harry Potter and the Chamber of Secrets*

II. LOCATION: Chamber of Secrets

III. TECH TALK: The final thirty or so feet of the Basilisk in the Chamber were created digitally from the cyberscanned model.

IV. DESCRIPTION FROM *HARRY POTTER AND THE CHAMBER OF SECRETS* BOOK, CHAPTER SEVENTEEN:

"The enormous serpent, bright, poisonous green, thick as an oak trunk, had raised itself high in the air and its great blunt head was weaving drunkenly between the pillars."

CHAMBER OF SECRETS

Production designer Stuart Craig felt that as the Chamber of Secrets was created by Salazar Slytherin, it should be like a Slytherin "temple." This secret part of the castle was placed in the dungeons of Hogwarts, but the Basilisk would be able to prowl the pipes of the school looking for victims when set free.

Craig and his team visited the sewers of London to study their architecture for inspiration. As Hogwarts castle is set in Scotland, Craig had molds made of real rock faces there for the walls, in order to match the cliffs and mountains in the highlands. Slytherin's head was molded in polystyrene and then dressed by sculptor Andrew Holder to match the rock face. The Chamber was one of the biggest sets constructed for the films, at 250 feet long by 120 feet wide. It was also supposed to be of an incredible depth, but the tallest stage at the time at Leavesden Studios reached only 28 feet. So, Craig solved this by creating an illusion of depth: His idea was that the Chamber was flooded, and so only the head of a statue of Salazar Slytherin could be seen. The water was only a foot deep and dyed black to give it that sense of depth.

In *Harry Potter and the Deathly Hallows – Part 2*, the Chamber is opened again when Ron Weasley and Hermione Granger retrieve a Basilisk tooth in order to destroy a Horcrux. As the Chamber was seen briefly, a digital reconstruction was created and the scene was filmed entirely against green screen.

> " *The Chamber of Secrets has been opened.*"
> WRITING ON A HOGWARTS
> CORRIDOR WALL
> *Harry Potter and the Chamber of Secrets* film

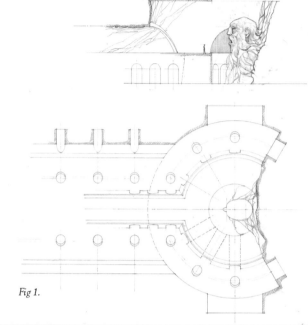

Fig 1.

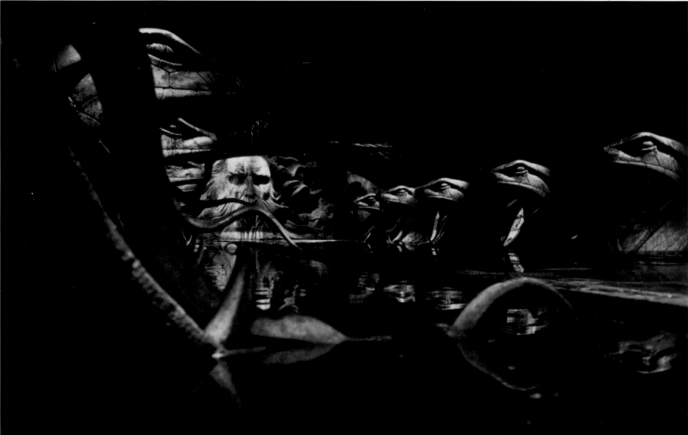

Fig 2.

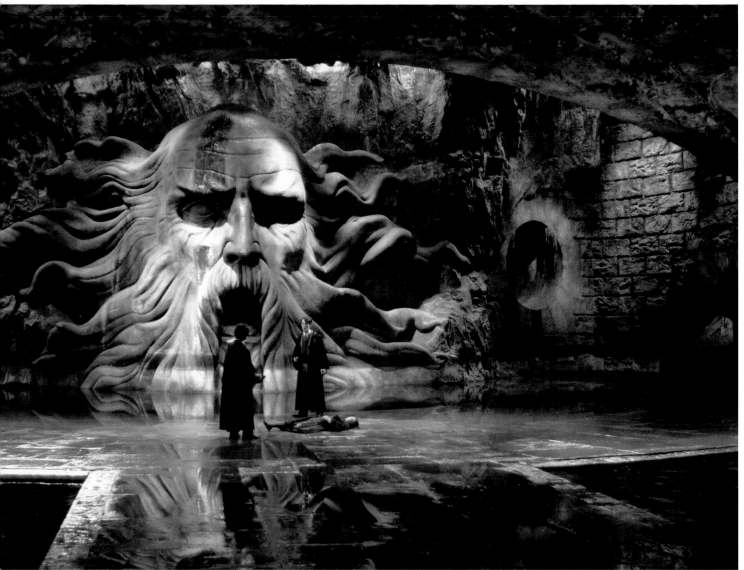

Fig 3.

Fig 4.

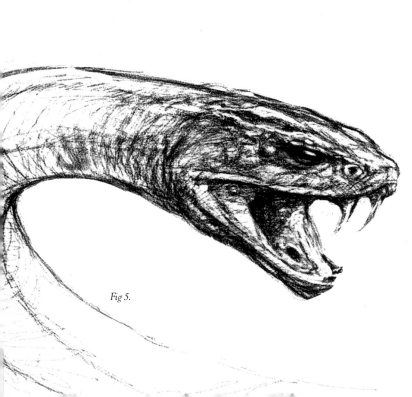

Fig 5.

Fig 1. Designs for the Chamber of Secrets; Fig 2.–4. Stills from *Harry Potter and the Chamber of Secrets* show the size of the room and the scale of the molds used; Fig 5. A sketch of the Basilisk by Stuart Craig.

Dementor

Dementors, spectral Dark creatures that guard Azkaban, are sent to Hogwarts to find and bring back Sirius Black in *Harry Potter and the Prisoner of Azkaban*. Harry is deeply affected by their soul-draining power, so Professor Lupin teaches him the Patronus Charm to shield himself. In *Harry Potter and the Order of the Phoenix*, Dementors attack Harry and Dudley Dursley (Harry Melling) in Little Whinging, but Harry manages to drive them away. Dementors fight on Voldemort's side in *Harry Potter and the Deathly Hallows – Parts 1* and *2*.

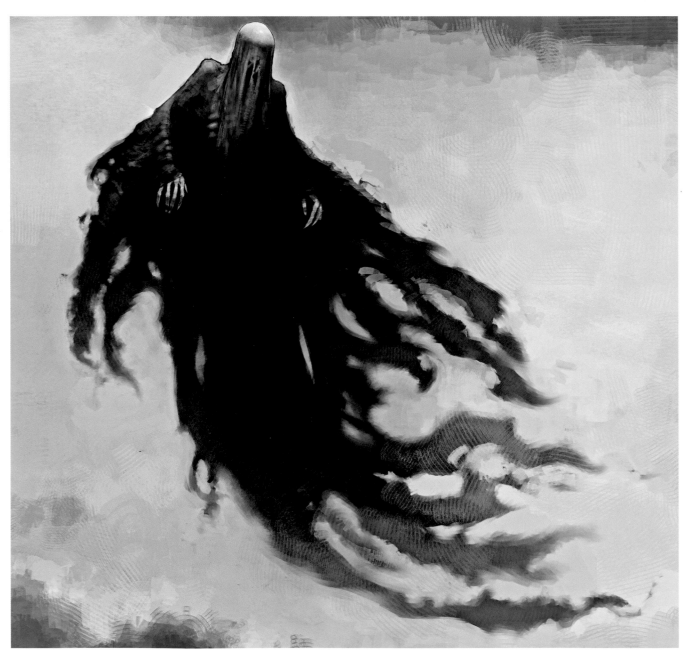

Fig 1. (above) The skeletal structure of a Dementor disappears within its hooded and tattered cloak in artwork by Rob Bliss for *Harry Potter and the Prisoner of Azkaban*; Fig 2. (opposite) A concept sketch of Harry's encounter with the Dementors during a Quidditch game by Rob Bliss for *Prisoner of Azkaban*.

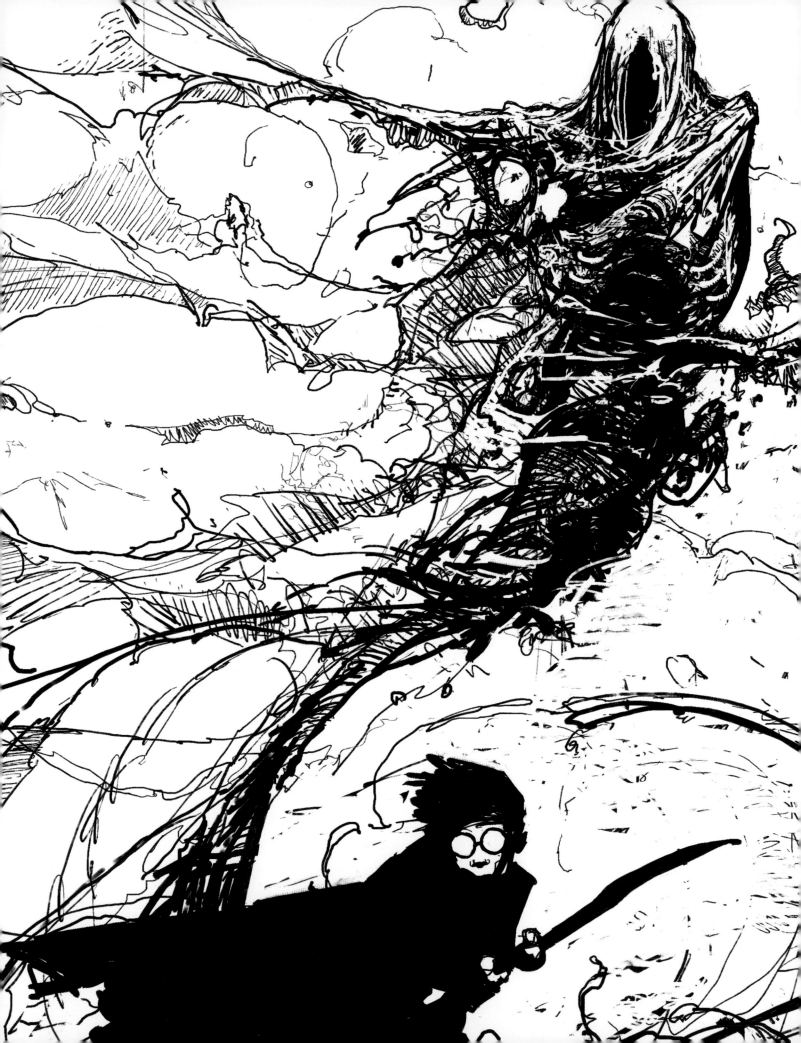

Figs 1–3. Dementor construction in the creature shop for *Harry Potter and the Prisoner of Azkaban* included a collaboration with the costume department; Fig 4. Dementor studies by Rob Bliss for *Harry Potter and the Prisoner of Azkaban*; Fig 5. Dementors float above the Hogwarts grounds in artwork by Andrew Williamson for *Prisoner of Azkaban*; Fig 6. Hooded Dementors envisioned by Olga Dugina and Andrej Dugin.

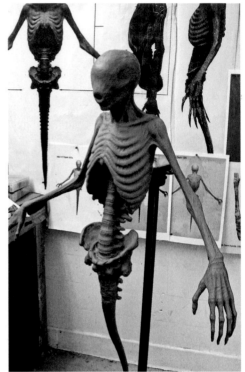

Fig 1.

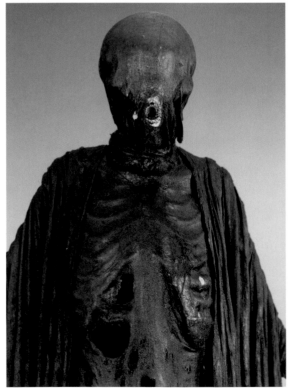

Fig 2.

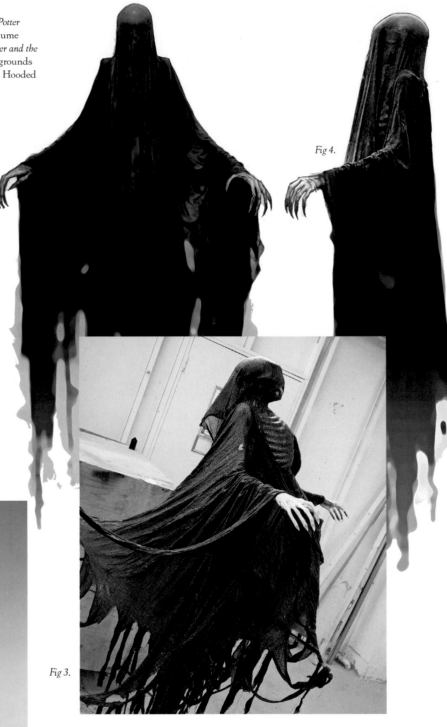

Fig 4.

Fig 3.

"*Dementors are amongst the foulest creatures to walk this earth. They feed on every good feeling, every happy memory, until a person is left with absolutely nothing but his worst experiences.*"

—Remus Lupin
Harry Potter and the Prisoner of Azkaban film

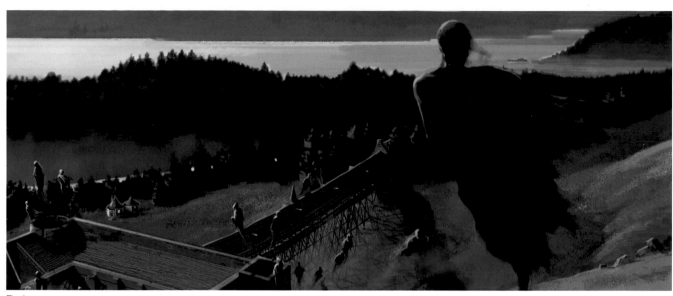

Fig 5.

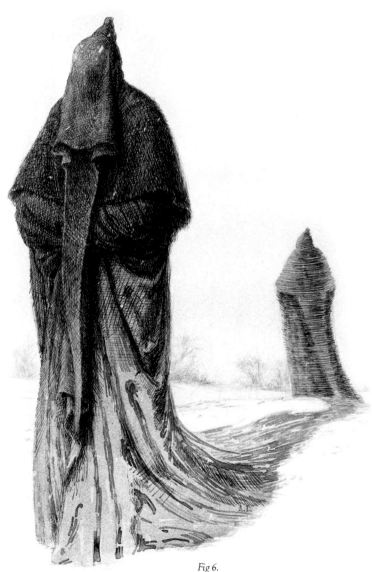

Fig 6.

Dementors are ethereal, insubstantial creatures with no perceptible structure. The visual development artists on *Harry Potter and the Prisoner of Azkaban* developed a veiled, skeletal shape that could suggest some anatomical frame when the Dementors glided or hovered in the air, and swathed them in shroud-like black robes that hung from their skulls. Inspired by the skeletons of birds, costume designer Jany Temime cut these robes based on the bones in their wings as she worked with the creature department to create a model to be cyberscanned. The designers also referenced embalmed bodies, whose wrappings were rotting and coming off, and overlaid textures on the Dementors that gave the appearance of layers of decay.

The Dementors do not talk and only needed a mouth-like opening to drain happiness from their victims with the Dementor's "kiss," so movement was the key to communicating these chilling, menacing characters. The filmmakers had hoped to bring the Dementors to life with a practical effect. They shot tests of fabric-covered Dementor models using different wind and lighting effects, and ran the film backward or in slow motion, but were not satisfied with the results. Puppeteer Basil Twist was brought in to test the same ideas, this time in an underwater environment, in hopes of portraying a slow and forceful creature. These tests captured what the filmmakers envisioned, but it was realized that using this process would make it almost impossible to repeat the same motion, so it was decided that the Dementors needed to be computer-generated. The footage of the underwater tests was an important reference tool, and the digital artists expanded upon it with effects that gave the Dementors their own realistic gravity, making them stealthy and unearthly.

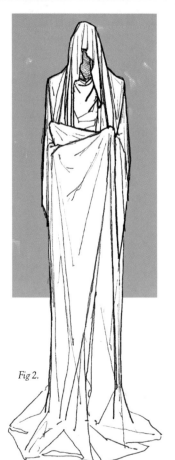

Fig 1. (above) Evocative artwork of a Dementor by Rob Bliss for *Harry Potter and the Prisoner of Azkaban;*
Fig 2. Dementor study by Rob Bliss for *Harry Potter and the Prisoner of Azkaban.*

Fig 2.

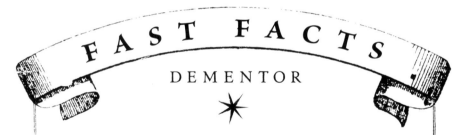

FAST FACTS

DEMENTOR

✴

I. FIRST FILM APPEARANCE: *Harry Potter and the Prisoner of Azkaban*

II. ADDITIONAL FILM APPEARANCES: *Harry Potter and the Order of the Phoenix, Harry Potter and the Deathly Hallows – Parts 1 and 2*

III. LOCATIONS: Hogwarts Express, Hogwarts castle, an underpass adjacent to Privet Drive, Ministry of Magic

IV. TECH TALK: The costume department based their interpretation of the Dementors' robes on birds' wings.

V. DESCRIPTION FROM *HARRY POTTER AND THE PRISONER OF AZKABAN* BOOK, CHAPTER FIVE:

"Standing in the doorway . . . was a cloaked figure that towered to the ceiling. Its face was completely hidden beneath its hood. . . . There was a hand protruding from the cloak and it was glistening, grayish, slimy-looking, and scabbed, like something dead that had decayed in water."

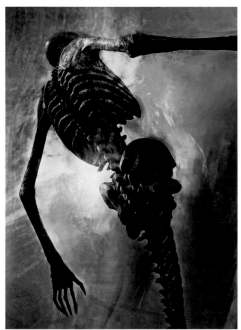

Fig 3.

Fig 4.

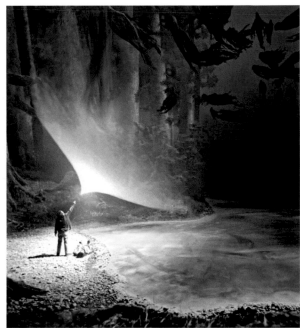

Fig 5.

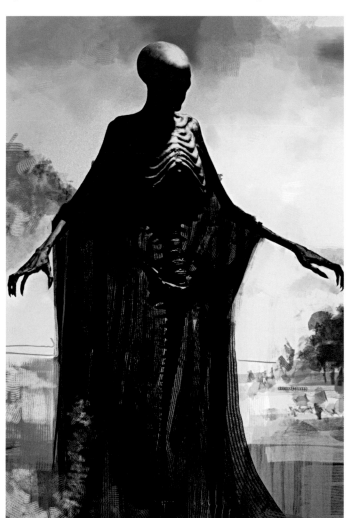

Fig 6.

"
*Dementors are vicious creatures. They will not
distinguish between the one they hunt and the one
who gets in their way. . . . It is not in the nature of a
Dementor to be forgiving."*

—ALBUS DUMBLEDORE
Harry Potter and the Prisoner of Azkaban film

For *Harry Potter and the Order of the Phoenix*, the Dementors were reconstructed, as the filmmakers wanted more of the Dementors to be seen. Their hoods were removed and their robes were drawn back in order to reveal their skulls and chests. They also needed substantial arms and articulated hands in order to hold Harry up against the underpass wall during their attack. Initially, the designers refashioned the hanging strips of their tattered shrouds to act as arms, akin to an octopus's, but found too many arms were distracting and so dropped the idea for two humanlike appendages.

Figs 3. & 4. Rob Bliss explores Dementor textures and shades in detailed concept art; Fig 5. Harry Potter (Daniel Radcliffe) uses the Patronus Charm to disperse the Dementors and protect Sirius Black (Gary Oldman) in a scene from *Prisoner of Azkaban*; Fig 6. Visual development art by Rob Bliss for *Harry Potter and the Prisoner of Azkaban* that is intended to give the creature shop ideas for paint colors and textures.

Inferius

The Inferi are another type of creature that is unique to the Harry Potter series. They are resurrected corpses, bewitched by any Dark wizard. In *Harry Potter and the Half-Blood Prince*, Harry Potter and Albus Dumbledore (Michael Gambon) must gain entry into a sea cave to retrieve the Slytherin locket they believe to be a Horcrux. They achieve their task, but their way out is blocked by a reanimated mass of gray, skeletal Inferi emerging from the lake, bewitched by Lord Voldemort. It takes a firestorm to destroy the Inferi and allow Harry and Dumbledore to escape.

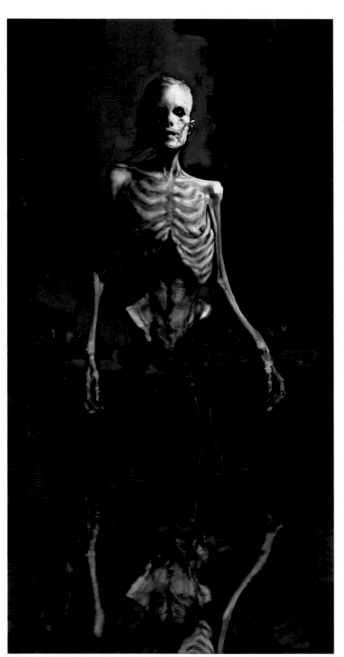

Fig 1.

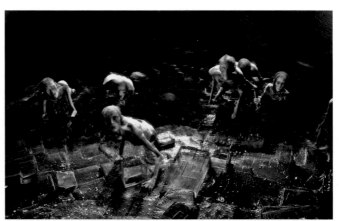

Fig 2.

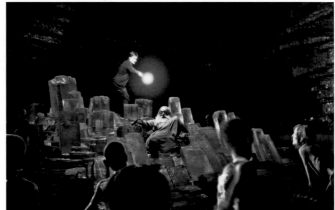

Fig 3.

Fig 1. Inferi concept art by Rob Bliss for *Harry Potter and the Half-Blood Prince*; Figs 2. & 3. Digital composites of the Inferi invading the cave's crystal island; Fig 4. (opposite) Harry attempts to stop the Inferi and protect Dumbledore in artwork by Adam Brockbank.

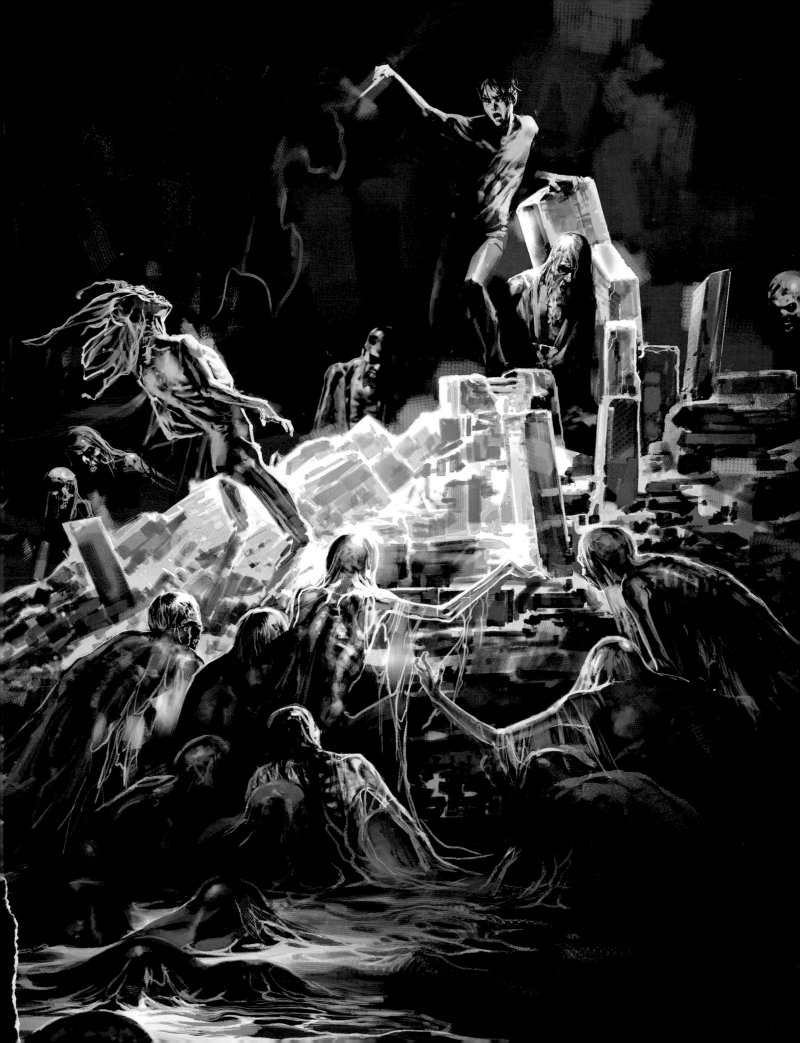

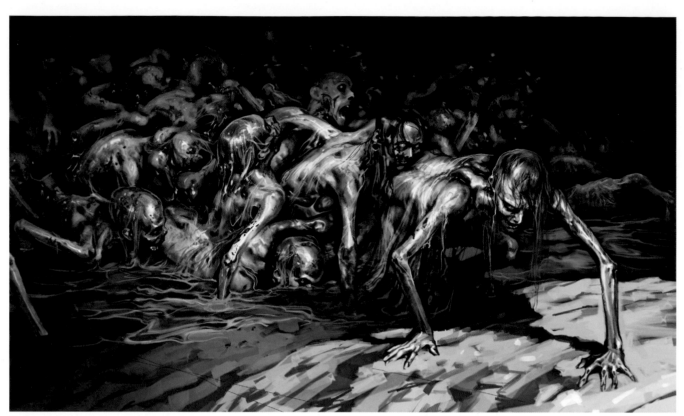

Fig 1.

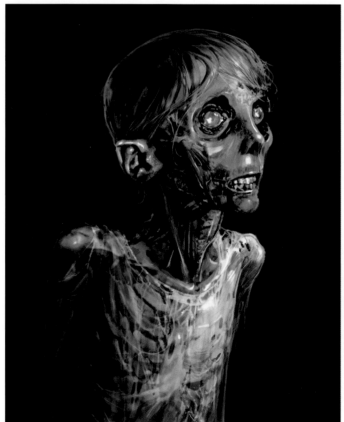

Fig 2.

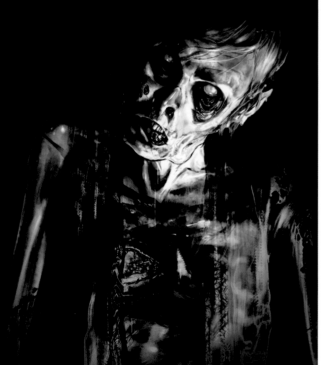

Fig 3.

The Inferi in the *Half-Blood Prince* film are grotesque and frightening, their sole task being to stop anyone from leaving the cave. However, though these "undead" beings are driven by Dark forces, they are actually victims of Voldemort. The filmmakers wanted these creatures to be as threatening as they needed to be, and yet elicit sympathy from the audience. Visual development research included studying woodcuts from the Middle Ages, with their images of misshapen and monstrous beings, and classic works such as *Dante's Inferno* and *Paradise Lost*. The artists even viewed photos of bodies that had been submerged in water to observe how that would affect the color and texture of their skin.

Inferi were meant to be wholly computer-generated creatures, and so models of a male and a female version were sculpted at full size to be cyberscanned, but were not yet painted. Painting was done inside the computer, where tones of gray and black were layered on, and a texture was added that would give them the essence of having once been flesh-covered. Additionally, a digital skeleton was incorporated into their bodies and tested for movement.

An important mandate was that the Inferi not be mistaken for zombies, and director David Yates even screened zombie films to avoid anything that appeared cliched or based on that archetype. An Inferius had to be a creature never before seen on-screen. A cast of men and women were filmed in motion capture emerging from the lake and grabbing at Harry so that the Inferi's expressions and movements would realistically resemble that of anyone coming out of water. Daniel Radcliffe (Harry Potter) was shot in a water tank being dragged underwater and then embraced by a female Inferi to ensure that the actor's hair and clothes floated naturally. Then the digital Inferi, which included two children, were added to that footage. It took forty-five weeks for thirty-one artists to create the Inferi, who were on screen for only two minutes.

One of the most challenging effects for the scene was creating the firestorm that enables Harry and Dumbledore to escape. Lighting was a crucial consideration, and the digital artists needed to develop new software that would allow them to work with the large numbers of Inferi as well as the fire itself so that they combined seamlessly. This meant lighting the Inferi by the flames that encircled and destroyed them. The fire was designed to look fierce and combustive.

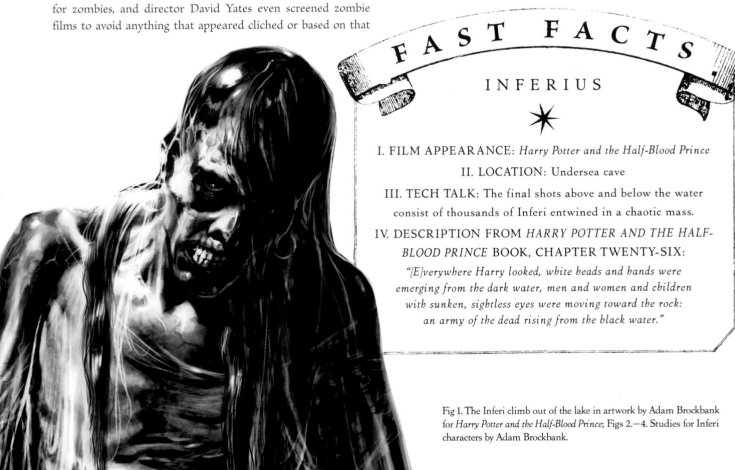

FAST FACTS

INFERIUS

✳

I. FILM APPEARANCE: *Harry Potter and the Half-Blood Prince*

II. LOCATION: Undersea cave

III. TECH TALK: The final shots above and below the water consist of thousands of Inferi entwined in a chaotic mass.

IV. DESCRIPTION FROM *HARRY POTTER AND THE HALF-BLOOD PRINCE* BOOK, CHAPTER TWENTY-SIX:

"[E]verywhere Harry looked, white heads and hands were emerging from the dark water, men and women and children with sunken, sightless eyes were moving toward the rock: an army of the dead rising from the black water."

Fig 1. The Inferi climb out of the lake in artwork by Adam Brockbank for *Harry Potter and the Half-Blood Prince*; Figs 2.—4. Studies for Inferi characters by Adam Brockbank.

Fig 4.

Troll

Trolls are described as extremely large creatures, roughly twelve feet in height. They are very dangerous and very stupid. A troll first appears in the films when, during the Halloween feast in *Harry Potter and the Sorcerer's Stone*, Professor Quirrell races into the Great Hall shrieking that there is a troll in the dungeon. When Harry Potter and Ron Weasley find Hermione Granger—and the troll—in the girls' bathroom, they manage to defeat it when Ron is finally able to correctly use the *Wingardium Leviosa* Charm.

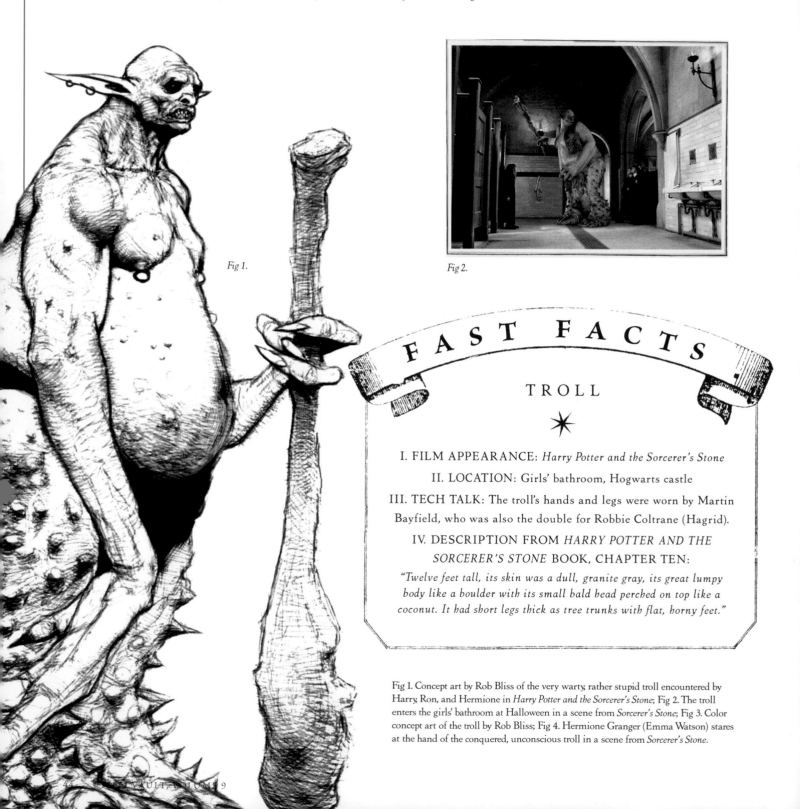

Fig 1.

Fig 2.

FAST FACTS

TROLL

✳

I. FILM APPEARANCE: *Harry Potter and the Sorcerer's Stone*

II. LOCATION: Girls' bathroom, Hogwarts castle

III. TECH TALK: The troll's hands and legs were worn by Martin Bayfield, who was also the double for Robbie Coltrane (Hagrid).

IV. DESCRIPTION FROM *HARRY POTTER AND THE SORCERER'S STONE* BOOK, CHAPTER TEN:

"Twelve feet tall, its skin was a dull, granite gray, its great lumpy body like a boulder with its small bald head perched on top like a coconut. It had short legs thick as tree trunks with flat, horny feet."

Fig 1. Concept art by Rob Bliss of the very warty, rather stupid troll encountered by Harry, Ron, and Hermione in *Harry Potter and the Sorcerer's Stone*; Fig 2. The troll enters the girls' bathroom at Halloween in a scene from *Sorcerer's Stone*; Fig 3. Color concept art of the troll by Rob Bliss; Fig 4. Hermione Granger (Emma Watson) stares at the hand of the conquered, unconscious troll in a scene from *Sorcerer's Stone*.

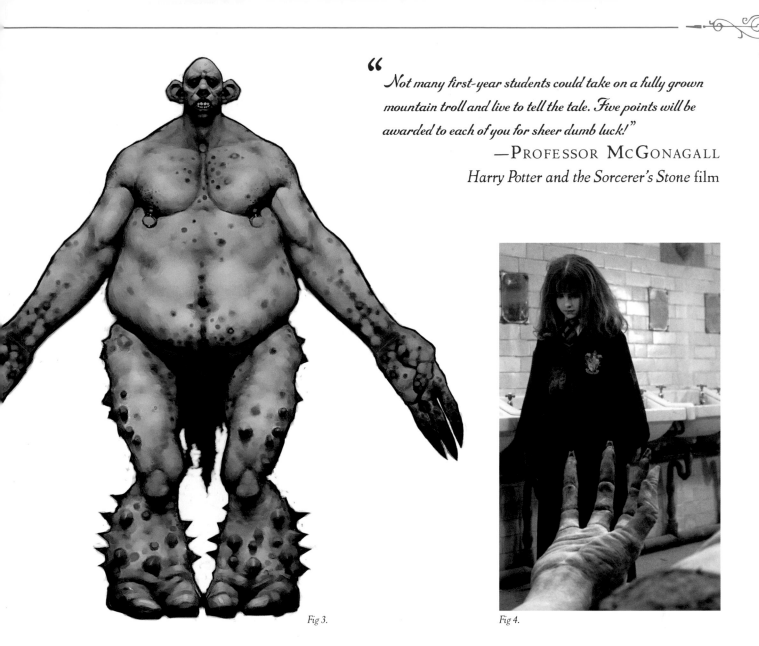

"
Not many first-year students could take on a fully grown mountain troll and live to tell the tale. Five points will be awarded to each of you for sheer dumb luck!"

—PROFESSOR MCGONAGALL

Harry Potter and the Sorcerer's Stone film

Fig 3.

Fig 4.

When concept artists were given a mountain troll to design, they knew it was a Dark creature but was seen in a not-so-dark comedic sequence. So, they decided that he should be ferocious but also convey a dopey look in his eyes, so that you hated him and didn't hate him at the same time.

To bring the troll to life, the filmmakers used several different types of visual and special effects techniques. First, the creature shop designed the troll based on the concept art and constructed a maquette that included the creature's vacant expression, two-toed limbs, and large spiky warts on his legs. This was cyberscanned into the computer. An actor performing in a troll costume was filmed by a traditional camera for digital reference, as *Sorcerer's Stone* was shot years before motion-capture technology became prevalent. The troll's hands and a pair of full-size silicone "troll trousers" representing his legs were produced, for scenes where the troll interacted with Hermione Granger (Emma Watson). These trousers were worn by Martin Bayfield, who also performed Hagrid in long shots.

Practical sight gags were filmed in live-action: the sink being destroyed above Hermione and the stall doors exploding, both from a strike of the troll's club, which was operated by a pneumatic rig. A hydraulic rig raised Daniel Radcliffe (Harry Potter) to "drop" on top of the troll's shoulders and swing about (there was a bit of a digital Harry in the scene). Finally, the troll is taken down by Ron Weasley and crashes onto the floor, unconscious. A twelve-foot troll was sculpted in clay and then molded in silicone, which gave a natural sag to his flesh. An animatronic head gave the fully painted troll's face and fingers movement so he could twitch and make the students think he was waking up.

This full-scale troll was referenced by the visual effects artists for his digital version. Medical photographs were researched for the troll's skin, and his layer of carbuncles and grime was enhanced with more dirt on his wrinkles and warts. Hair was added in tufts on his head and armpits. For the troll's movements, the crew imagined him like a four-year-old child, knocking down everything in his way, like a walking bulldozer.

Giant

The films of the Harry Potter series showcased a large number of creatures, none so large as the giants. Giants can reach up to twenty feet in height, only four feet taller than trolls, and only as proportionately higher in intelligence. Prior to the events of *Harry Potter and the Order of the Phoenix,* as Voldemort is gathering his strength and his supporters, Hagrid is sent to parlay with the giants. During this journey, he finds his giant half brother, Grawp.

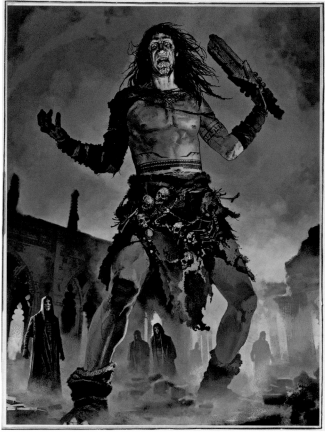

Fig 1.

"
Well, they're not that hard ter find, ter be perfectly honest. They're so big, see?"
—RUBEUS HAGRID
Harry Potter and the Order of the Phoenix film

Fig 2.

"

I tried to convince 'em ter join the cause. . . .

But I wasn't the only one that was trying to win them over.»

—RUBEUS HAGRID

Harry Potter and the Order of the Phoenix film

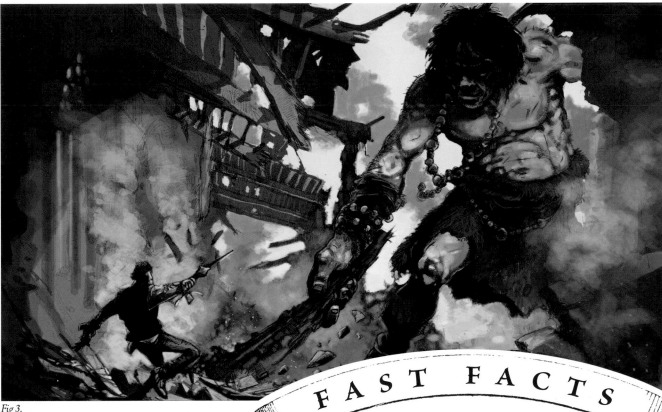

Fig 3.

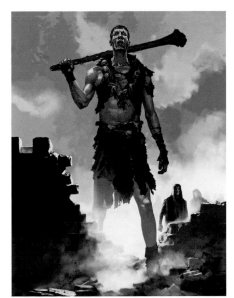

Fig 4.

FAST FACTS

GIANT

✴

I. FILM APPEARANCE: *Harry Potter and the Deathly Hallows – Part 2*

II. LOCATION: Hogwarts grounds

III. DESIGN NOTE: The clubs the giants used as weapons were digitally "fashioned" from small trees.

IV. DESCRIPTION FROM *HARRY POTTER AND THE DEATHLY HALLOWS* BOOK, CHAPTER THIRTY-TWO:

"A giant stood before him, twenty feet high, its head hidden in shadow, nothing but its treelike, hairy shins illuminated by light from the castle doors."

Fig 1. Artwork by Adam Brockbank of a skull-draped giant during the Battle of Hogwarts in *Harry Potter and the Deathly Hallows – Part 2*; Fig 2. Half-giant Hagrid juxtaposed with his giant half brother, Grawp, visualized by Adam Brockbank for *Harry Potter and the Order of the Phoenix*; Concept art by visual development artists Julian Caldow (Fig 3.) and Rob Bliss (Fig 4.) of giants in the climactic battle scene of *Harry Potter and the Deathly Hallows – Part 2*.

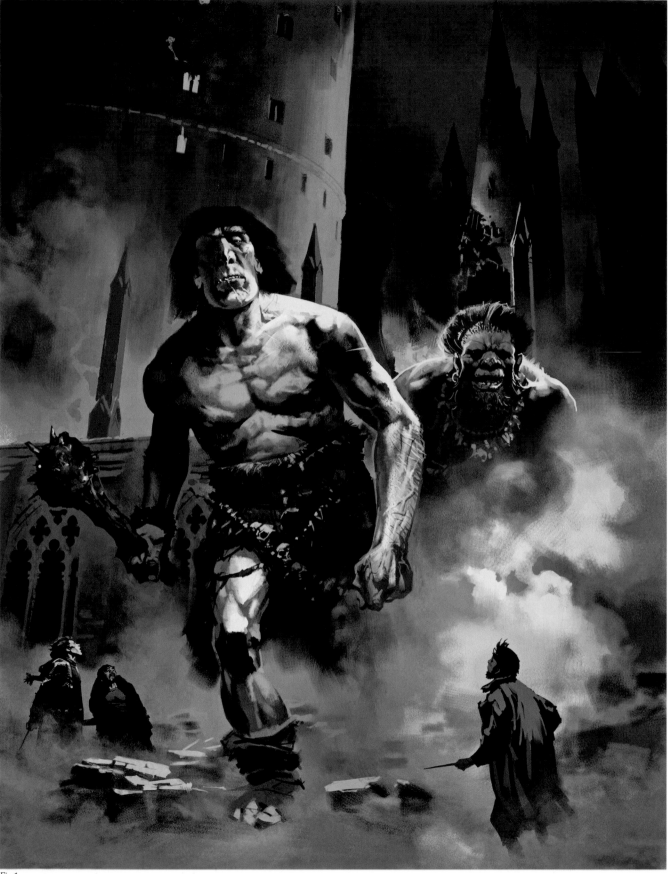

Fig 1.

The giants who participate in the battle of Hogwarts in *Harry Potter and the Deathly Hallows – Part 2* were to be computer-generated, but the digital crew knew it would be beneficial to start the design process with film of live-action actors. Prosthetics were created to scale up features on the actors' faces. Actors of varying oversized proportions wore the prosthetic makeup, along with loincloths, and were filmed running on treadmills. Then these green-screened movements were imported into a digital format. The giants' faces were scaled up again and distorted to lessen their human features. The bottom half of the giants' legs was made broader to suggest a lower center of gravity, and some were given feet with elephant-like toes. The giants' costume design included belts of skulls and human teeth, and hairstyles adorned with branches and leaves.

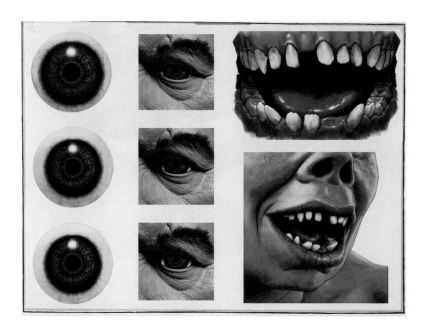

Fig 1. Students stare up at the fighting giants in *Harry Potter and the Deathly Hallows – Part 2* in artwork by Adam Brockbank; Fig 2. (above) Studies of Grawp's eyes and mouth by Adam Brockbank for *Harry Potter and the Order of the Phoenix*; Fig 3. Digital studies of giant head variations for *Deathly Hallows – Part 2*.

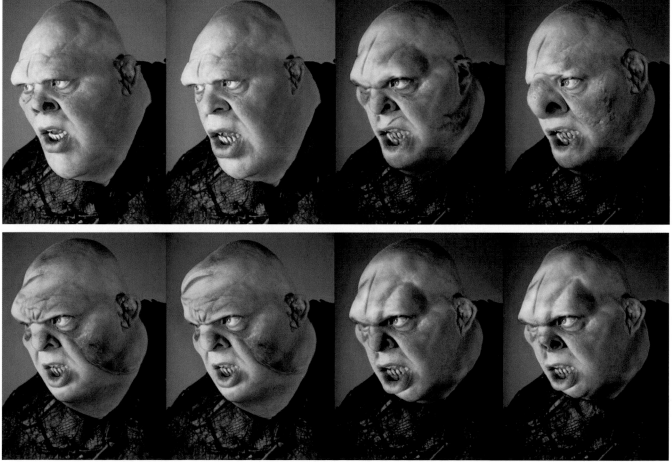

Fig 3.

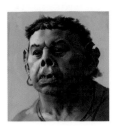

GRAWP

In *Harry Potter and the Order of the Phoenix*, half-giant Hagrid brings Harry Potter, Hermione Granger, and Ron Weasley to meet his half brother, Grawp, who he has hidden in the Forbidden Forest. This sixteen-foot-tall giant isn't a Dark creature, but he sure could be scary at first glance. Although fully computer generated, the creature effects shop constructed Grawp's head at full scale in an economical move to explore the finer details of his skin and hair, which always present challenges in CGI. Additionally, Grawp's head was used on the Forbidden Forest set in *Harry Potter and the Order of the Phoenix* for the actors' benefit as a sight line and as reference for the cinematography and lighting crews. A puppeteer dressed in a blue-screen suit was raised via a hydraulically controlled rig to the height of sixteen feet to enact the character. Grawp's arms were also constructed practically and operated by the puppeteer, which was important in gauging how far they would reach in order to block the scene. And Grawp's right hand was created to use in front of a green screen. Emma Watson (Hermione Granger) and Imelda Staunton (Dolores Umbridge) were filmed riding a motion-controlled giant's hand as part of being picked up by Grawp, then the hand was replaced by its digital version and the two elements were painstakingly composited together.

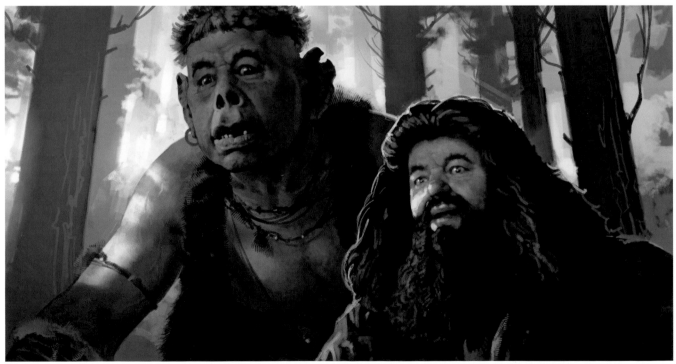

Fig 1.

" *He's completely harmless, just like I said.*
A little high-spirited is all."

—RUBEUS HAGRID
Harry Potter and the Order of the Phoenix film

" Grawp! Put me down ... Now."

—HERMIONE GRANGER
Harry Potter and the Order of the Phoenix film

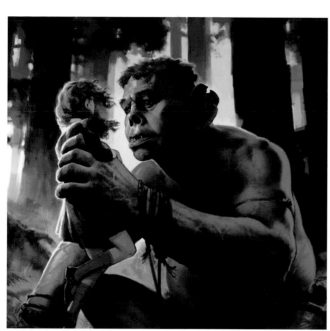

Fig 2.

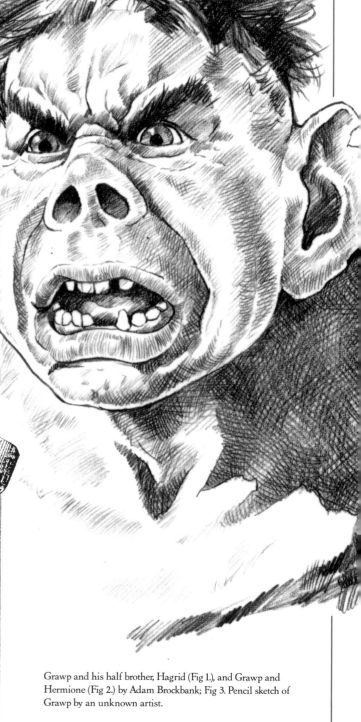

FAST FACTS

GRAWP

✶

I. FILM APPEARANCE: *Harry Potter and the Order of the Phoenix*

II. LOCATION: Forbidden Forest

III. TECH TALK: Motion capture footage of
actor Tony Maudsley enacting Grawp's lines and
movements was shot as performance reference.

IV. DESCRIPTION FROM *HARRY POTTER AND THE
ORDER OF THE PHOENIX* BOOK, CHAPTER THIRTY:

*"What Harry had taken to be a vast mossy boulder to the left
of the great earthen mound he now recognized as Grawp's
head. It was much larger in proportion to the body than a
human head, and was almost perfectly round and covered with
tightly curling, close-growing hair the color of bracken."*

Grawp and his half brother, Hagrid (Fig 1.), and Grawp and
Hermione (Fig 2.) by Adam Brockbank; Fig 3. Pencil sketch of
Grawp by an unknown artist.

Nagini

Nagini the snake is Lord Voldemort's companion and a Horcrux. Nagini tries to kill Arthur Weasley at the Ministry of Magic in *Harry Potter and the Order of the Phoenix*, but fails. The snake appears in a terrifying scene at Godric's Hollow in *Harry Potter and the Deathly Hallows – Part 1* as she attempts to kill Harry, but narrowly fails again. In order for Voldemort to be destroyed, Nagini needs to be killed, a task that is accomplished by Neville Longbottom wielding the Sword of Gryffindor in *Harry Potter and the Deathly Hallows – Part 2*.

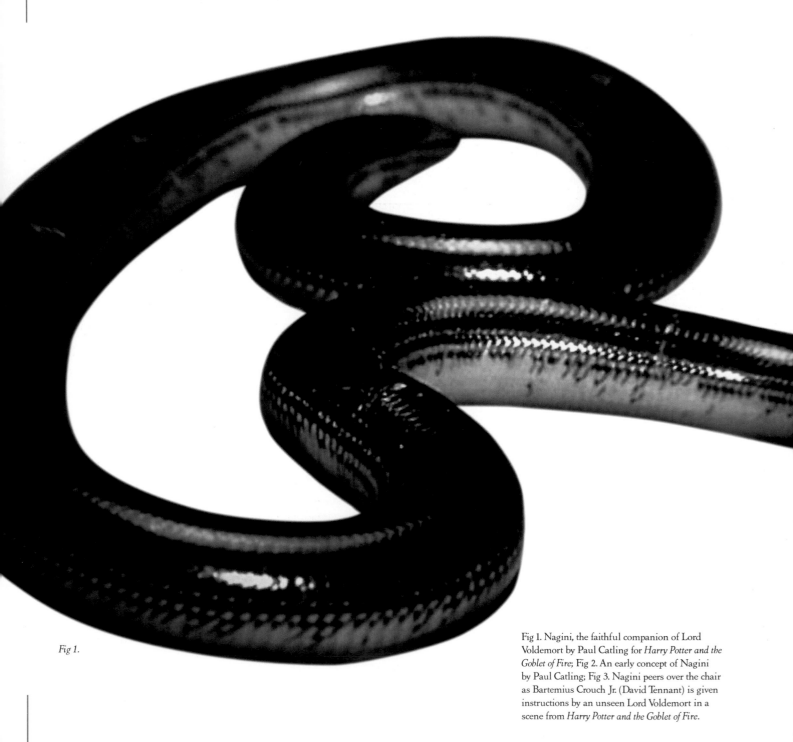

Fig 1.

Fig 1. Nagini, the faithful companion of Lord Voldemort by Paul Catling for *Harry Potter and the Goblet of Fire*; Fig 2. An early concept of Nagini by Paul Catling; Fig 3. Nagini peers over the chair as Bartemius Crouch Jr. (David Tennant) is given instructions by an unseen Lord Voldemort in a scene from *Harry Potter and the Goblet of Fire*.

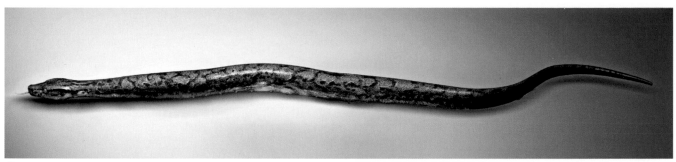

Fig 2.

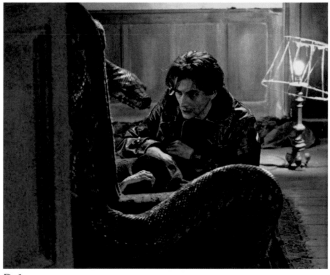

Fig 3.

" *Kill the snake. Kill the snake and then it's just him.*"

—HARRY POTTER

Harry Potter and the Deathly Hallows – Part 2 film

The Nagini that Harry sees in his disturbing visions throughout *Harry Potter and the Goblet of Fire* was a mash-up of python and anaconda breeds, and was roughly twenty feet long. The creature shop created a to-scale model that was painted and then cyberscanned, and the same model was used for *Harry Potter and the Order of the Phoenix*. Nagini's role was considerably larger in *Harry Potter and the Deathly Hallows – Parts 1* and *2*, and so the designer revamped her to be an even more threatening presence. A live python was studied by the digital crew, who not only sketched and filmed the snake but took high-resolution images of individual scales. These images were used to create new textures and colors that added iridescence and a snakeskin's reflective properties. Nagini was still primarily python, but with added cobra- and viper-like movements. Viper characteristics were introduced into her face for more animation of her brows and eyes, and sharper fangs protruded from her mouth.

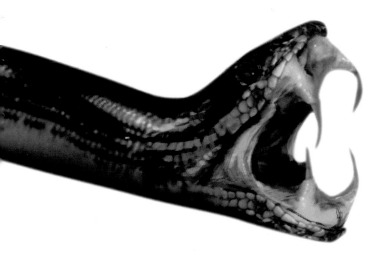

" *Nagini . . . dinner.*"

—LORD VOLDEMORT

Harry Potter and the Deathly Hallows – Part 1 film

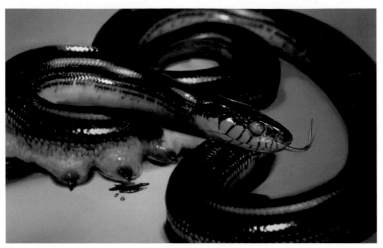

Fig 1.

For the sequence of Nagini bursting through the body of Bathilda Bagshot to attack Harry in *Deathly Hallows – Part 1*, an amalgamation of digital versions of Bathilda (Hazel Douglas) and Harry (Daniel Radcliffe) and live-action shots was employed. Nagini slithers up through Bathilda's head in a CGI construction that was composited onto a live-action shot of the actress. Harry's battle with the snake was a composite of a 3D digital model of Daniel Radcliffe and live shots of Radcliffe "fighting" against a team of crew members, wearing green-screen gloves, holding him down. The crew was removed digitally, and the snake was added for the final shot.

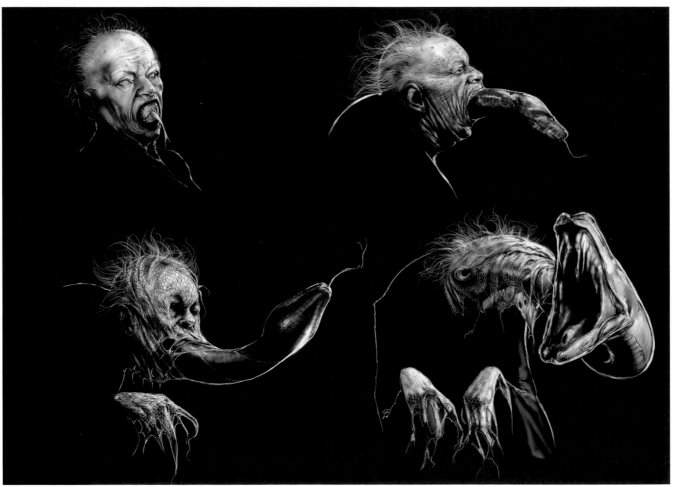

Fig 2.

Fig 1. In *Harry Potter and the Goblet of Fire*, Nagini was intended to suckle the embryonic form of Lord Voldemort. Concept art by Paul Catling; Fig 2. Paul Catling artwork of Nagini bursting through the mouth of Bathilda Bagshot in *Harry Potter and the Deathly Hallows – Part 1*; Fig 3. Digital template of Nagini in the graveyard at the end of *Goblet of Fire*; Fig 4. the finished concept as seen on-screen; Fig 5. Another view of Nagini's surprising entrance by Paul Catling for *Deathly Hallows – Part 1*.

FAST FACTS

NAGINI

✳

I. FIRST FILM APPEARANCE:
Harry Potter and the Goblet of Fire

II. ADDITIONAL FILM APPEARANCES:
Harry Potter and the Half-Blood Prince, Harry Potter and the Deathly Hallows – Parts 1 and *2*

III. OWNER: Lord Voldemort

IV. DESCRIPTION FROM *HARRY POTTER AND THE DEATHLY HALLOWS* BOOK, CHAPTER ONE:
"The huge snake . . . came to rest across Voldemort's shoulders: its neck the thickness of a man's thigh; its eyes with their vertical slits for pupils, unblinking."

Fig 3.

Fig 4.

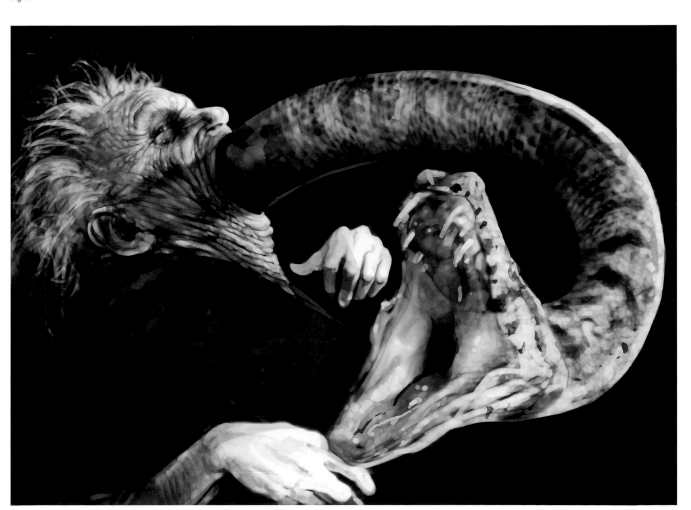

Fig 5.

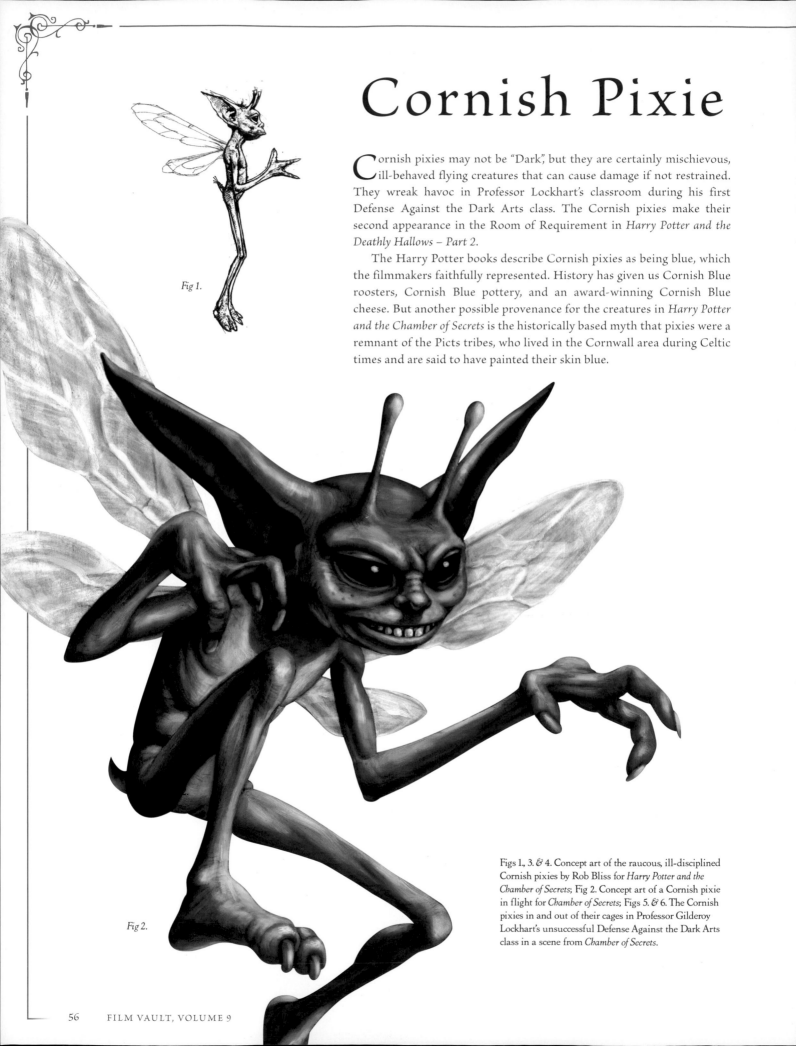

Cornish Pixie

Cornish pixies may not be "Dark", but they are certainly mischievous, ill-behaved flying creatures that can cause damage if not restrained. They wreak havoc in Professor Lockhart's classroom during his first Defense Against the Dark Arts class. The Cornish pixies make their second appearance in the Room of Requirement in *Harry Potter and the Deathly Hallows – Part 2*.

The Harry Potter books describe Cornish pixies as being blue, which the filmmakers faithfully represented. History has given us Cornish Blue roosters, Cornish Blue pottery, and an award-winning Cornish Blue cheese. But another possible provenance for the creatures in *Harry Potter and the Chamber of Secrets* is the historically based myth that pixies were a remnant of the Picts tribes, who lived in the Cornwall area during Celtic times and are said to have painted their skin blue.

Fig 1.

Fig 2.

Figs 1, 3. & 4. Concept art of the raucous, ill-disciplined Cornish pixies by Rob Bliss for *Harry Potter and the Chamber of Secrets*; Fig 2. Concept art of a Cornish pixie in flight for *Chamber of Secrets*; Figs 5. & 6. The Cornish pixies in and out of their cages in Professor Gilderoy Lockhart's unsuccessful Defense Against the Dark Arts class in a scene from *Chamber of Secrets*.

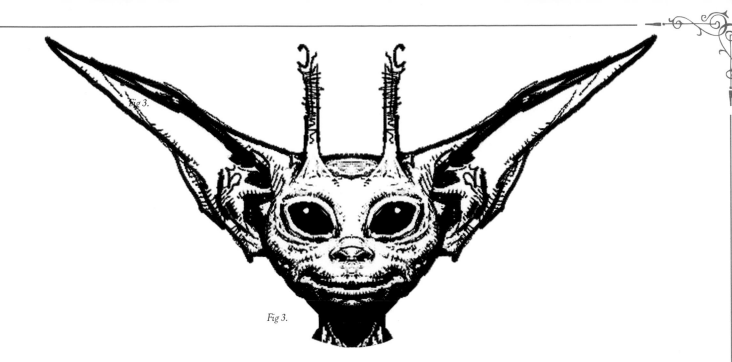

Fig 3.

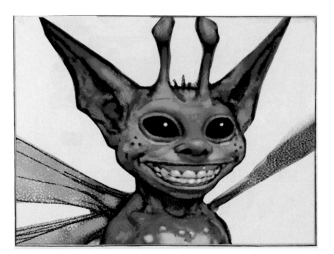

Fig 4.

For the films, a scale model of a Cornish pixie was created and painted an electric blue, and was then cyberscanned and animated by the digital artists. Depth of field was created by scattering the twenty or so pixies between the background, the foreground, and the middle at different heights in the filmed classroom. Actor Matthew Lewis (Neville Longbottom) had clips placed behind his ears to push them forward, to create the effect of two pixies pulling him up by the ears to suspend him above the room.

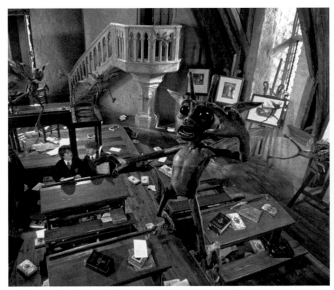

Fig 5.

Fig 6.

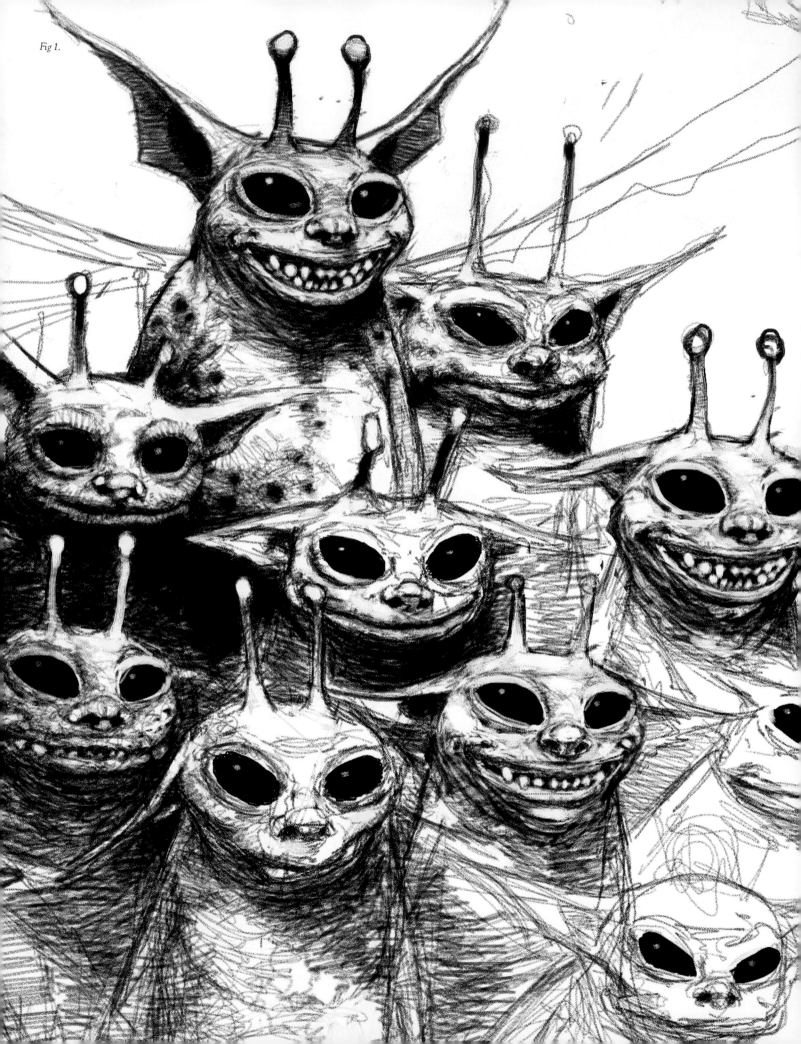

Fig 1.

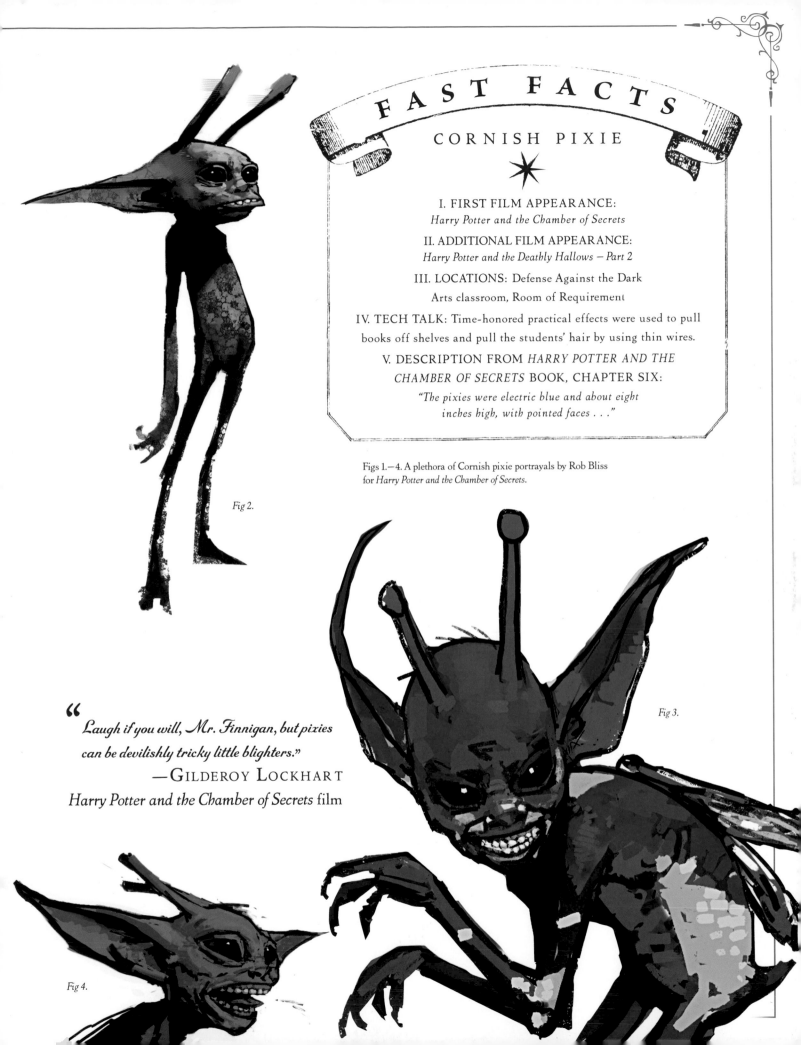

FAST FACTS

CORNISH PIXIE

✳

I. FIRST FILM APPEARANCE:
Harry Potter and the Chamber of Secrets

II. ADDITIONAL FILM APPEARANCE:
Harry Potter and the Deathly Hallows – Part 2

III. LOCATIONS: Defense Against the Dark
Arts classroom, Room of Requirement

IV. TECH TALK: Time-honored practical effects were used to pull
books off shelves and pull the students' hair by using thin wires.

V. DESCRIPTION FROM *HARRY POTTER AND THE
CHAMBER OF SECRETS* BOOK, CHAPTER SIX:
*"The pixies were electric blue and about eight
inches high, with pointed faces . . ."*

Figs 1.–4. A plethora of Cornish pixie portrayals by Rob Bliss
for *Harry Potter and the Chamber of Secrets*.

Fig 2.

Fig 3.

" *Laugh if you will, Mr. Finnigan, but pixies
can be devilishly tricky little blighters.*"
—GILDEROY LOCKHART
Harry Potter and the Chamber of Secrets film

Fig 4.

Gnome

In the initial script for *Harry Potter and the Chamber of Secrets*, the Weasley twins and Ron must de-gnome the garden behind The Burrow, a punishment for using the flying Ford Anglia. Gnomes are not really Dark creatures, but they are known to be hostile and troublesome. But it is a sad reality in moviemaking that scenes written in the original scripts are sometimes cut before filming begins, and so the gnome scene was never shot. Concept art of the gnomes was created, but the scene was edited out of the final shooting script. However, for *Harry Potter and the Half-Blood Prince*, the prop shop created a gold-skinned, tutu-wearing immobilized gnome that the Weasleys use as a Christmas tree topper.

In *Harry Potter and the Deathly Hallows – Part 1*, Luna Lovegood tells Harry that she has been bitten by one near the wedding tent at the wedding of Bill Weasley and Fleur Delacour.

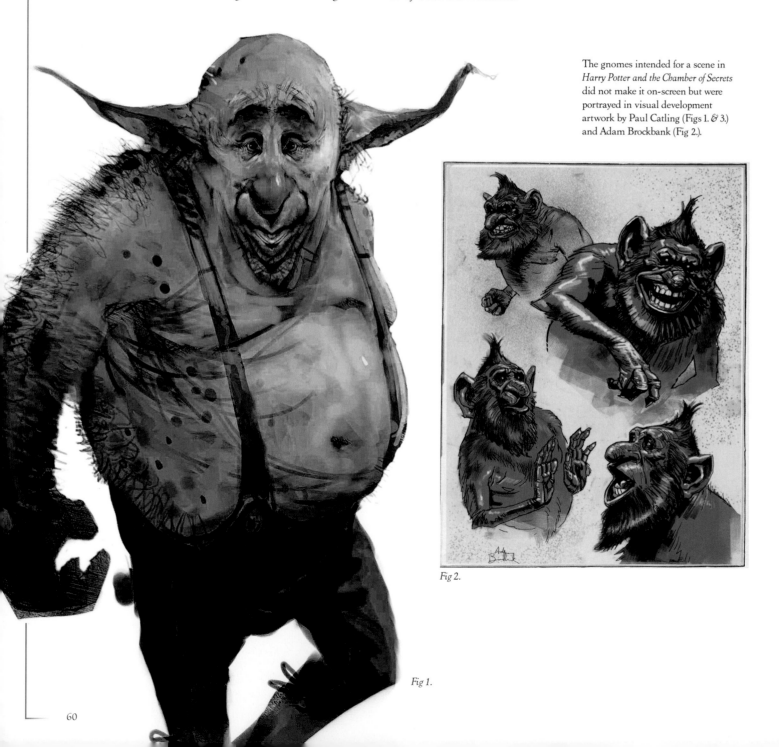

The gnomes intended for a scene in *Harry Potter and the Chamber of Secrets* did not make it on-screen but were portrayed in visual development artwork by Paul Catling (Figs 1. & 3.) and Adam Brockbank (Fig 2.).

Fig 2.

Fig 1.

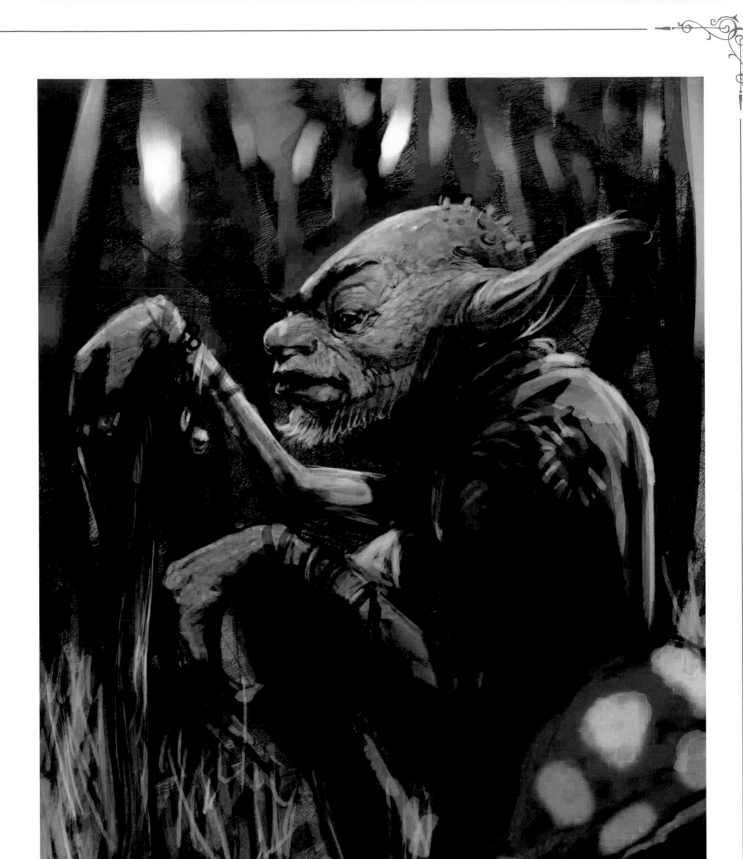

Fig 3.

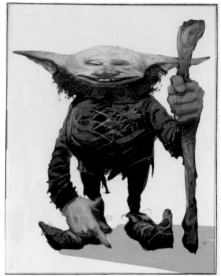

Fig 1.

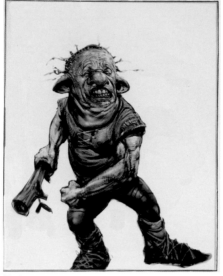

Fig 2.

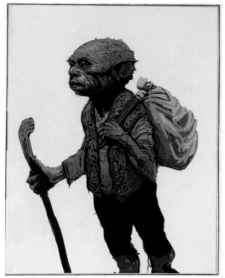

Fig 3.

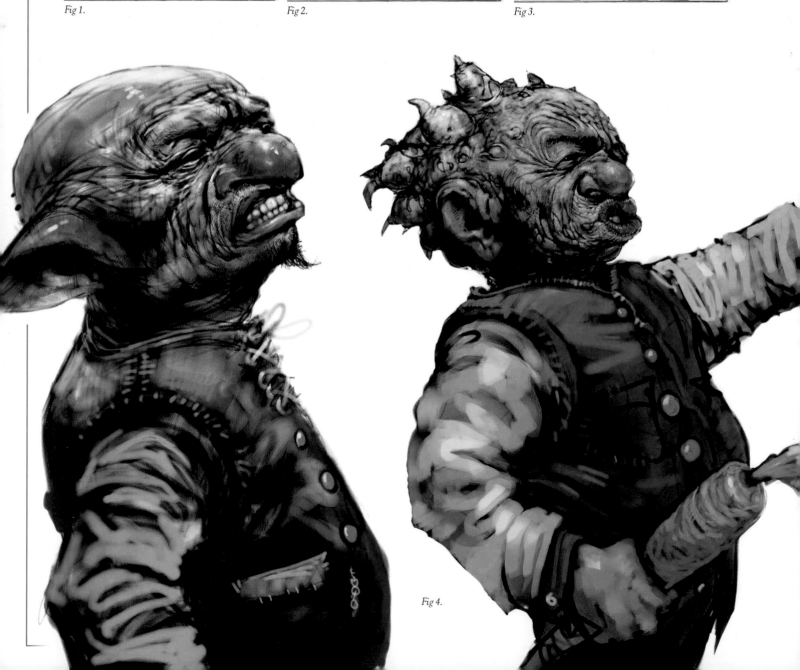

Fig 4.

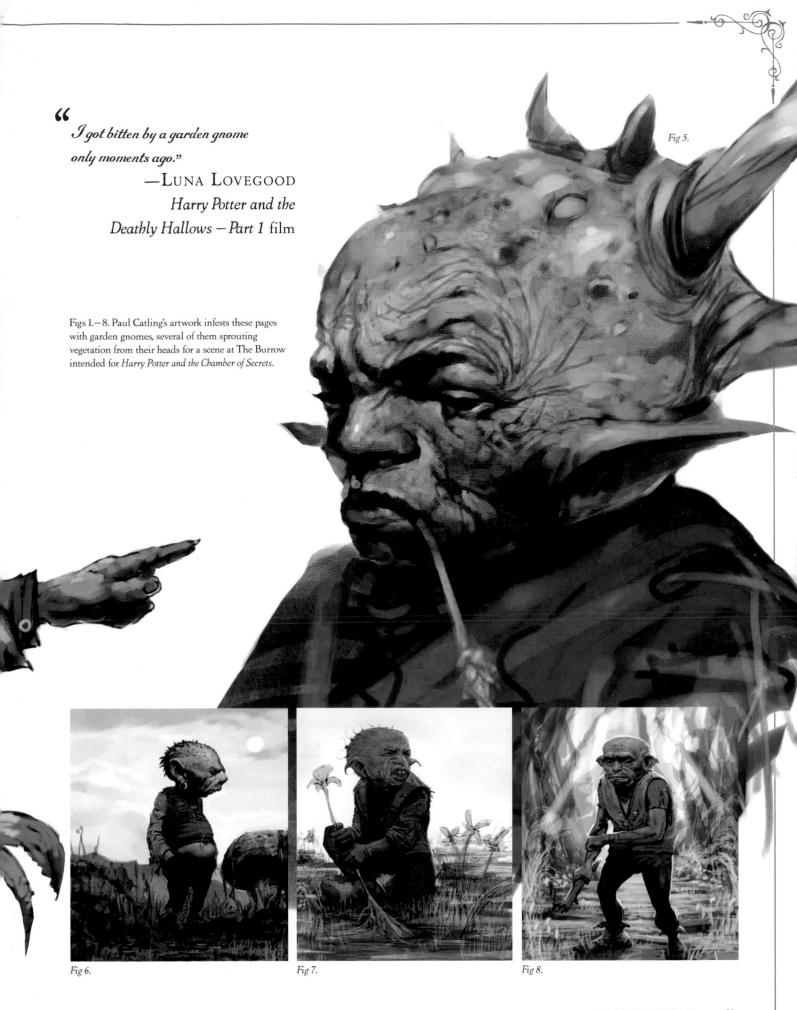

"*I got bitten by a garden gnome only moments ago.*"

—LUNA LOVEGOOD
Harry Potter and the Deathly Hallows – Part 1 film

Figs 1.–8. Paul Catling's artwork infests these pages with garden gnomes, several of them sprouting vegetation from their heads for a scene at The Burrow intended for *Harry Potter and the Chamber of Secrets*.

Fig 5.

Fig 6.

Fig 7.

Fig 8.

Copyright © 2020 Warner Bros. Entertainment Inc. HARRY POTTER characters, names and related indicia are © & ™ Warner Bros. Entertainment Inc. WB SHIELD: ™ & © WBEI. WIZARDING WORLD trademark and logo © & ™ Warner Bros. Entertainment Inc. Publishing Rights © JKR. (s20)

INSIGHT
EDITIONS

PO Box 3088
San Rafael, CA 94912
www.insighteditions.com

 Find us on Facebook: www.facebook.com/InsightEditions
 Follow us on Twitter: @insighteditions

All rights reserved. Published by Insight Editions, San Rafael, California, in 2020. No part of this book may be reproduced in any form without written permission from the publisher.

Library of Congress Cataloging-in-Publication Data available.

ISBN: 978-1-68383-833-3

Publisher: Raoul Goff
President: Kate Jerome
Associate Publisher: Vanessa Lopez
Creative Director: Chrissy Kwasnik
Design Support: Megan Sinead Harris
Editor: Greg Solano
Managing Editor: Lauren LePera
Senior Production Editor: Rachel Anderson
Production Director/Subsidiary Rights: Lina s Palma
Senior Production Manager: Greg Steffen

Written by Jody Revenson

Insight Editions, in association with Roots of Peace, will plant two trees for each tree used in the manufacturing of this book. Roots of Peace is an internationally renowned humanitarian organization dedicated to eradicating land mines worldwide and converting war-torn lands into productive farms and wildlife habitats. Roots of Peace will plant two million fruit and nut trees in Afghanistan and provide farmers there with the skills and support necessary for sustainable land use.

Manufactured in China by Insight Editions

10 9 8 7 6 5 4 3 2 1